LIGHTING ESSENTIALS

A Subject-Centric Approach
for Digital Photographers

Don Giannatti

AMHERST MEDIA, INC. ■ BUFFALO, NY

ACKNOWLEDGEMENTS

A big thank-you to my wonderful family: my wife Marian and my three girls, Shanna, Michaila, and Alissa— especially for kicking Dad into the office with the admonishment to not come out until I had written another thousand words.

Special production thanks go to these guys who really chipped in and helped me get some last-minute images: Charles Howard (www.charleshowardphoto.com); Billy Kidd; David Womble; and Ernie Lagerquist.

Finally, thanks to the models who so graciously and patiently worked with me not only on this book, but on all my productions. These include Jazmin, Haley, Stephanie, Illia, Desean, Lynne, Rio, Katherine, Katlyn, Richelle, Amber Lee, Megan, and, of course, Briana.

I love having great friends.

Copyright © 2012 by Don Giannatti.
All rights reserved.

All photographs by the author unless otherwise noted.

Published by:
Amherst Media, Inc.
P.O. Box 586
Buffalo, N.Y. 14226
Fax: 716-874-4508
www.AmherstMedia.com

Publisher: Craig Alesse
Senior Editor/Production Manager: Michelle Perkins
Assistant Editor: Barbara A. Lynch-Johnt
Editorial Assistance from: Chris Gallant, Sally Jarzab, John S. Loder

ISBN-13: 978-1-60895-232-8
Library of Congress Control Number: 20111924258
Printed in Korea.
10 9 8 7 6 5 4 3 2 1

Check out Amherst Media's blogs at: http://portrait-photographer.blogspot.com/
http://weddingphotographer-amherstmedia.blogspot.com/

TABLE OF CONTENTS

INTRODUCTION

This is not a "beginner" book. There are no photographs of light stands and speedlights. I hope that you already know what they are. This book is to help you think about the light that these tools provide, and what that light does when it is rendered on a subject. By focusing on the subject, we can make all kinds of decisions about the gear we are using.

SUBJECT-CENTRIC LIGHTING... WHAT DOES THAT MEAN?

Light is a substance we cannot taste or smell. We can't touch it or bend it. In fact, we can see light only when it reflects from something—and that "something" is the subject of our photograph. The light can reflect from the subject with soft tonalities or with wildly exaggerated color. It can also carve the texture by highlighting the raised areas and defining the unlit areas as shadow. Edge light can separate our subject from a darker background, while the chiaroscuro effect of gentle gradients can add depth to a portrait.

Light is the tool that we use to reveal those attributes, but it is the *subject* that embodies them. Therefore, subject-centric lighting means we think of the subject first. What qualities does the subject possess that the light will react with? How will the light react and what will it reveal? What elements do we wish the subject to present? Will the subject present soft edges with open shadows or distinct lines of highlight and shadow? Should the subject merge with the background or be separated from it?

IT'S ALL ABOUT CHOICES

There are no right or wrong answers, there are simply choices that we as photographers must make. Those

IMAGE I-1. It was an overcast day on the beach in Mexico. I wanted a feeling of sunlight on Jasmin so a flash was used as the main light. This was placed at a distance and set at $2/3$ stop over the ambient. A second flash, set at 1 stop below the ambient, was used from the opposite side to open the shadows and make the shot look more natural. Previsualizing your results and creating them with your lighting tools is what we are going to be talking about in this book.

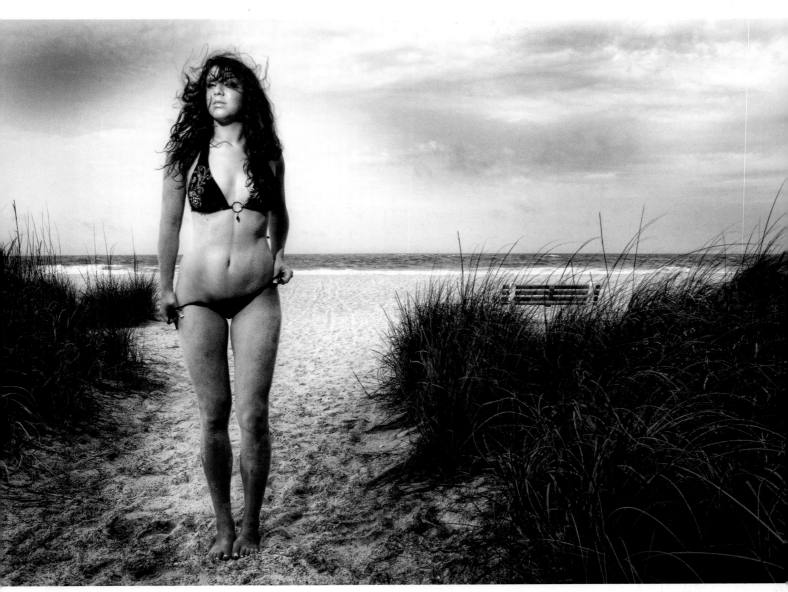

IMAGE I-2. Briana was photographed on the beach in Anna Maria, FL. Posed in the shadow of a large tree, Briana was 1.5 stops darker than the exposure of the beach and sky. The sun was behind a bit of high, overcast cloud cover, resulting in an exposure of f/11 at $^1/_{125}$ second at ISO 100. To approximate the look of the sunlight, without having Briana look directly into that very bright overcast sky, I placed a small speedlight on a stand at the same angle as the sun and at a distance that would give me f/11. The result is a small shadow under her chin and a "hard" light look that mimics the sunlight.

choices need to be made before the lights are set up and in position, and based on what we want our images to look like as prints or digital displays. We refer to that process as previsualization—knowing in advance what it is that should be achieved, then working toward that end. The tools we use are many and varied but the images we produce should not be the result of happenstance or luck. The decisions we make must be con-

scious choices that guide the image toward the what we saw in our heads way before we clicked the shutter.

I was once hired to shoot some images for a company that wanted to show how the pollution from an Arizona copper mine was (in their words) fouling the air with thick black billows of airborne death. I immediately knew how to show that smoke at its worst: backlight it. During the afternoon, I went to the town the smelter

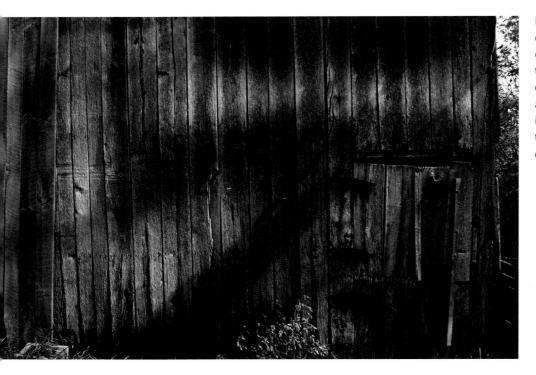

IMAGE I-3. Light from an oblique angle will define texture. This old barn in Ohio was grazed by the sunlight and the shadows of trees. You can see how much the texture is enhanced by the sidelight compared to the areas where the shadow dominates. Imagine if this was a subject's skin; enhancing the texture may not be what we'd want to do if the skin is not perfect.

was in and scouted a position that would show the sun setting behind the smoke. The result was simply scary; black smoke blocked the light and created a deep, high-contrast trail of darkness against the vibrant sky. As I drove past the smelter to the side lit directly by the sun, I took some additional shots for myself. In these, the smoke was front lit against a pale sky—and you could hardly make out the smoke at all. It looked like faint white streams against some soft clouds.

The subject was the same and the light was the same. What changed was the way the subject and the light interacted. In the scary smoke shot, the smoke blocked the sunlight and created a shadow of it. In the not-so-scary smoke shot, the sun simply bounced off of the particles, revealing no contrast. This is the essence of subject-centric lighting: considering the subject first, then applying the light because of what we know of the subject's ability to handle it.

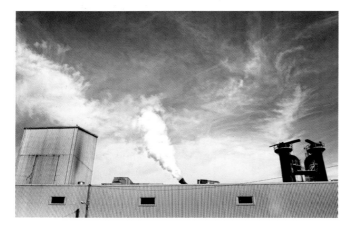
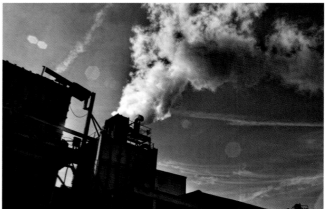

IMAGES I-4 AND I-5. On a recent trip through Ohio, I saw this factory with a lot of smoke coming out of the stack. I decided to do a shot from the front and one from the back to illustrate what I had done all those years before in Arizona. The front-lit shot shows a rather benign plume of white smoke against a brighter sky. The backlit image has a much different feel, doesn't it? The smoke is actually thick enough to block some of the light and go dark—looking very ominous against the deep blue sky.

1. HOW SUBJECT-CENTRIC LIGHTING WORKS TO YOUR ADVANTAGE

As a photography instructor and frequent visitor to many photography forums, I often hear the question "What kind of light should I use for _____?" Often, the reply from others is a list of gear and modifiers. Before I answer that question, I always ask some follow-ups: "What do you want the photograph to look like? What do you want to communicate with the image? What is the reason that you want to make the photograph?" There are a lot more questions, but these are the essential ones. Usually I don't get an answer because the photographer doesn't know what the image should look like; he can't see it in his head yet. Because he cannot see the final result in his head (or can't explain it in terms we can discuss), the lighting tool choice he makes will simply render *their* version of his picture, not *his* version.

PLANNING MAKES PERFECT

Think through the different results desired for the following subjects. How would you approach photographing them? This is the core of subject-centric lighting; understanding your subject and deciding what you want to say about it will help you make more confident creative choices throughout the session.

PRACTICE ASSIGNMENT: A Shiny Subject. You are hired to make photographs of meat-slicing machines. They are shiny aluminum and polished wood that will reflect everything. That means you will have to control what the subject reflects. Large softboxes, scrims, cards—whatever you use, you will see it in the chrome. Knowing this, you can create a lighting scheme that will render the units the way you want to see them.

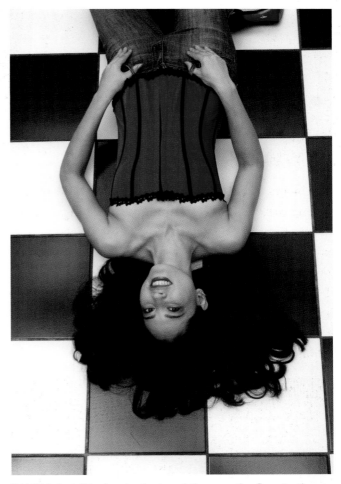

IMAGE 1-1. I like the checkerboard floor on the floor in the studio kitchen and thought it would make a bold background for this portrait of Lynne. Knowing that a large light source directed at the shiny floor would be reflected back to me, I bounced two Profoto flash heads off the white ceiling (two stories up) and let her be lit by the huge, soft light reflecting back.

PRACTICE ASSIGNMENT: An Edgy Look. You are to make an image of a musician for promotional use and possibly for a CD insert. The client wants the image to

be dramatic and show the experience etched into every line of the musician's face. He will have a saxophone in the shot; because of endorsement deals the musician has with the instrument's manufacturer, it must be shown as an important part of the image.

Knowing that you want drama and texture tells you that you don't want soft lighting; you need something a lot more directional. Choosing a smaller source will render the texture as desired and control the fall-off of the shadow to make sure it stays in the correct relationship to the highlight side. The direction of the light will be important as well; skimming it across the subject will lend a more edgy feel to the texture. Oh—and that saxophone will need some special attention, as well. It is a shiny, curved surface that will reflect whatever it sees. You may have to add some special lighting apparatus specifically to accentuate it.

So, now you can envision the results you want. Because you have it processed mentally, you can choose the lighting tools that will give you what you want.

PRACTICE ASSIGNMENT: A Portrait (At the Wrong Time of Day). A chef has opened a new restaurant and a magazine wants to feature him in a story. You are dispatched to do a shot of the chef in front of his new restaurant—but the session will be at 1:30PM, quite possibly the worst light of the day. The chef will be standing in the sunlight from almost directly overhead. Add to that the bright sun on the building behind the chef and you have the distinct possibility of a very bad photograph. This understanding of what the subject will look like in the existing light is the first step.

Knowing that the magazine expects a well-lit shot, you pack a softbox and a location kit with a flash powerful enough to beat the sun's exposure. This will allow you to create lighting with smooth transitions and a directional look. This will make the shot a winner for the magazine—and will likely mean more assignments.

In all of these examples, you can see how a successful image comes together when the photographer possesses both the creative ability to previsualize the results he wants and the technical expertise to choose appropriate light sources/modifiers to make the envisioned photograph a reality.

PRACTICAL EXAMPLES

SAMPLE SHOOT: Blending Flash and Ambient Light. This shot of Briana (**image 1-2**) was taken on the beach in Santa Barbara, CA. The sun had already gone down

IMAGE 1-2. This shot of Briana was taken on the beach in Santa Barbara, CA.

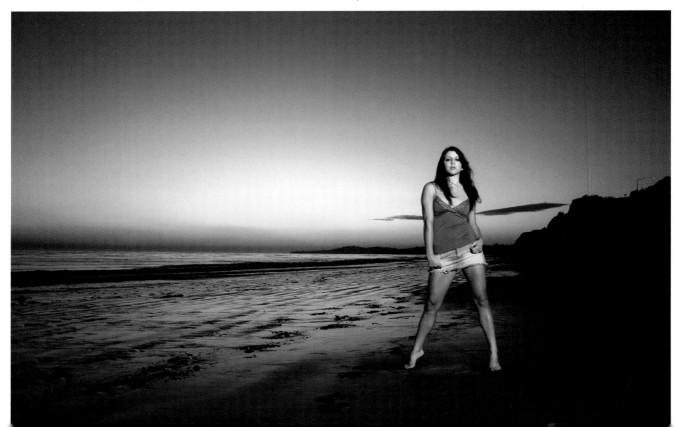

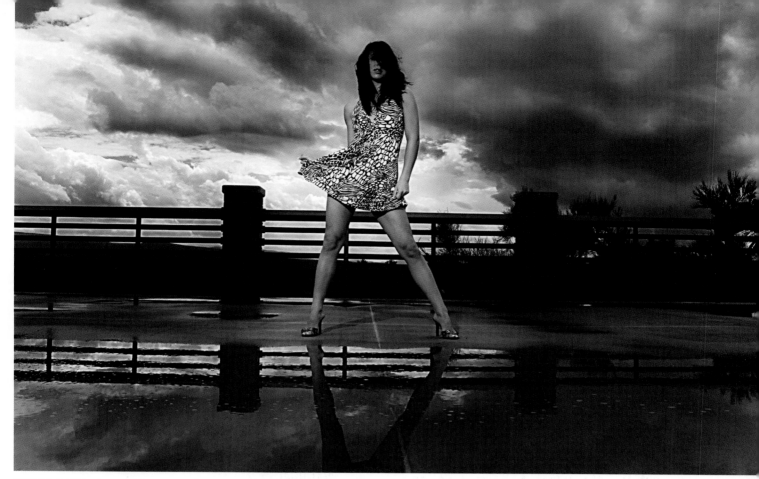

IMAGE 1-3. This shot of Briana was taken at a road stop near Sedona, AZ.

and I wanted to make the image with as much of a natural look as possible. As we dashed across traffic to the spot, I was evaluating the ambient light. Once I understood the ambient, I knew what the placement and power of the strobe should be. I initially used a speedlight with a very small umbrella for the main light, but it put far too much light on the foreground. I removed the umbrella, leaving the strobe bare, and moved it far enough back that the light hit Briana without too much falling on the sand in front of her. Zooming the flash head out (to 105mm on my Canon) and moving the light back produced very even light on the subject without a lot of spill. I ended up with an exposure of f/3.5 at $\frac{1}{100}$ second at ISO 100. This setting gave me a beautifully colored sky and a strobe setting that didn't require too much power at all. I chose a wide-angle lens to include more of the sky and foreground.

SAMPLE SHOOT: Another Approach to Blending Flash and Ambient Light. For the next image of Bri-

ana (**image 1-3**), taken at a road stop near Sedona, AZ, I used a different approach to the ambient light and strobe blend. I wanted Briana's monochromatic dress to be set against the wild, stormy sky. Knowing that the sky was very near f/16 at $\frac{1}{100}$ second at ISO 100, I decided to open the aperture to f/11 and choose a shutter speed of $\frac{1}{250}$ second. This resulted in a $\frac{1}{3}$ stop underexposure of the sky, giving it a bit more depth. Shooting at f/11 allowed me to place my flash at a greater distance from the subject (I didn't need the power to present f/16). I placed the speedlight atop a tall stand slightly to camera left. The dramatic sky is repeated in the water in front. The bright sky also provided a subtle edge light on the side of Briana opposite the speedlight.

SAMPLE SHOOT: Controlling the Sky. The next shot (**image 1-4**) was taken just off the road in the foothills of the Smoky Mountains. I had been admiring the amazing sky and the incredible clouds when I spotted the little farm out in the distance. The light was playing in

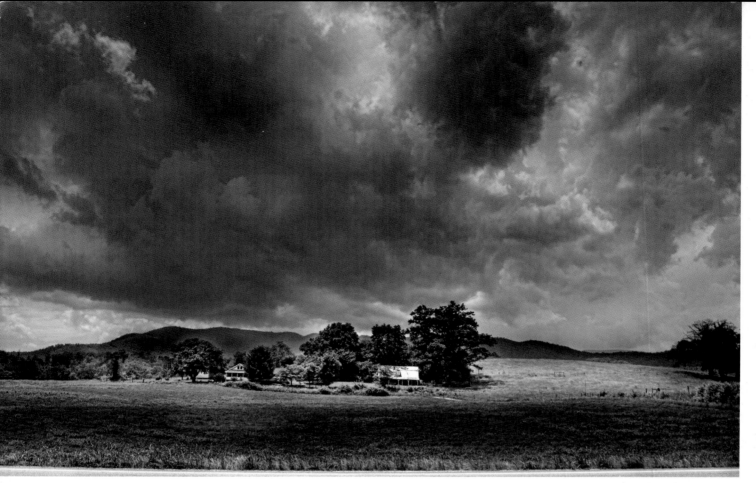

IMAGE 1-4. Adding a 2-stop gradient neutral-density filter balanced the sky and the foreground to create the image I envisioned.

IMAGE 1-5. Understanding the interaction of subjects and lighting allows you to take better advantage of "found" lighting situations.

IMAGE 1-6. A small softbox produced gentle lighting on Briana's face.

and out of the clouds and I had a feeling it would work out to something pretty cool. Grabbing my 20–35mm Canon L lens, I placed myself across the street from the farm and waited. I didn't have to wait long; the clouds opened up and illuminated the little farm very nicely.

Fortunately, I had already found the exposure that I wanted. I chose f/8 at $\frac{1}{400}$ second at ISO 100 (the Sunny 16 Rule) to make sure that the farm was correctly exposed. This setting, while perfect for the farm and foreground, made the sky much too bright. To compensate for this, and achieve the image I previsualized, I used a 2-stop gradient neutral-density filter to darken the clouds and make them more dramatic.

SAMPLE SHOOT: Found Lighting. This shot of Illia in Las Vegas (**image 1-5**) is the result of one of those moments that just happen when you are looking for light. I

came around the corner and saw some columns making large shadows in a little hallway. It was the small boxes of light that I loved, so they became a compositional element and something to exploit. The sun was low in the sky, allowing Illia to be lit from the front. (And the fact that it was dark in the space he was looking into helped keep the squinting down.) I shot this image at f/8 at $\frac{1}{250}$ second at ISO 100.

SAMPLE SHOOT: A Gentle Head Shot. For **image 1-6**, I had Briana at a posing table and used a small softbox in very close for my main light. I also surrounded her with white cards to open the shadow area and provide something bright for her cheeks and the underside of her chin to reflect. A zebra umbrella, placed above her and tuned to $\frac{1}{2}$ stop brighter than the main light, created a sense of backlighting.

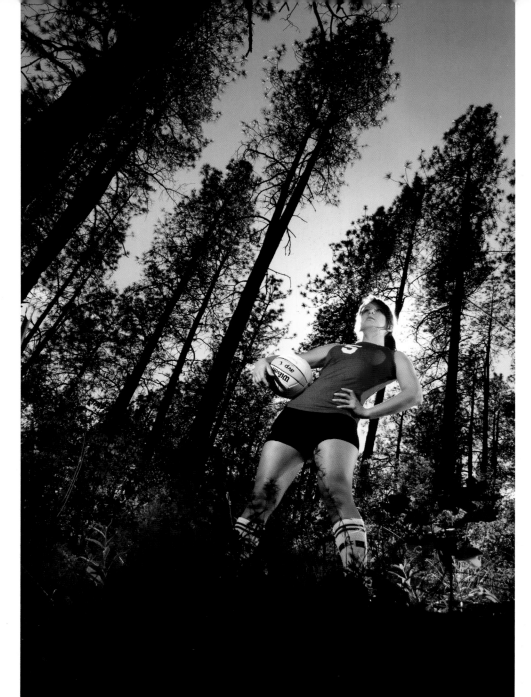

IMAGE 1-7. Shooting from a low angle, two strobes were used to create this heroic-looking image of Briana.

SAMPLE SHOOT: Dimensional Software Ad. This assignment came from Dimensional Software. The brief was to show a volleyball player in the forest, illustrating how using paperless software helped the environment by reducing the number of trees cut down. The company wanted the message to be subtle—not a crazy illustration of the software smashing loggers.

Briana was hired as the model. In the middle of the forest, we located a little patch of green. However, it was late summer and there hadn't been much rain, so I knew I might still have to do some Photoshop work to bring the desired color into the photograph.

For the first image (**image 1-7**), I wanted to make the volleyball player look heroic. Shooting from a low angle added this sense of drama. Because it would show less texture in the foreground and be more dramatic, I knew that a backlit shot would work best. Therefore, I brought a small speedlight kit and used two strobes

to light her, including the sun as a compositional element. One speedlight was used over my left shoulder, high enough to meet her face head on; the second was placed to camera right, adding a bit of rim light to Briana's shadow side. An exposure of f/10 and 1/125 second at ISO 100 was enough to get a nice color to the sky, because I blocked the sun with Briana's body.

In the end, this image was not selected; the client decided to use far more copy than we had envisioned in the first draft (**images 1-8 and 1-9**). Fortunately, whenever I am shooting a job without a full layout, I make sure to provide a variety of compositions. I move in for very tight shots and I shoot with a wide-angle lens, including plenty of negative space for text. As a designer and photographer, I know how appreciative other designers are when they are provided with a variety of shots to work with.

IN CLOSING

It takes practice and diligent experimentation to begin to see, really *see*, the light as it is presented back to the photographer. That is why many photographers find it easy to discuss tools but harder to discuss their effects. It is only when you begin to understand how each subject handles light that the various sources and modifiers at your disposal truly begin to function as tools—as devices that enable you to achieve the looks you envision. When this happens, the tools are no longer in charge, you are. You are making the decisions based on what you know about the subject and how it will render the light. And you know what tools will create the light you want to see rendered back from the subject you are photographing.

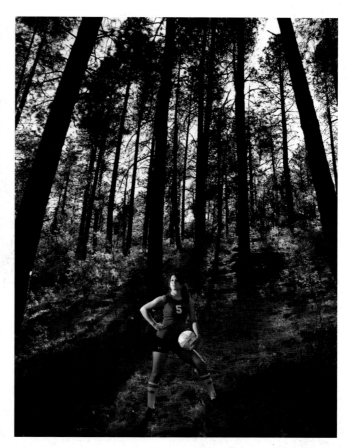

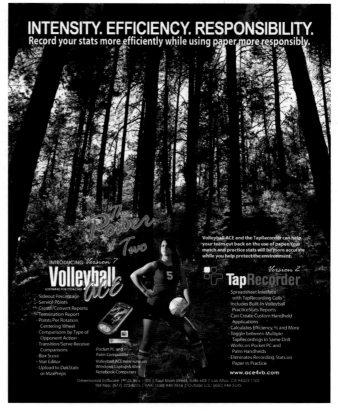

IMAGE 1-8. This shot I did with a lot of space around the model ended up being the one the client loved.

IMAGE 1-9. This is the final ad with all the headlines, logos, and text included. The image did very well for them in a magazine filled with dull, snapshot-like images of volleyball players.

2. PREVISUALIZATION IS KEY

Setting clear objectives for portraying your subjects is the critical first step in the larger process of previsualization, a term coined by photographer Ansel Adams to describe planning for what the image will look like as a finished print even before one begins to take exposure readings.

As photographers, we want to create images that communicate our ideas (or our client's ideas) and connect with viewers. Unfortunately, too many photographers attempt to design their way toward this goal as they shoot. They try this, then that, then that other thing, and then add a light and then add another light—argh! It isn't powerful and it isn't control. It's just sloppy. In the end, they have whatever image all that tinkering led them to, but it may not be the image they could have had if they had challenged themselves to previsualize the image. Previsualization is a concept that lies at the core of subject-centric lighting.

LEARNING TO PREVISUALIZE

The ability to visualize my images didn't happen to me overnight. It took a long, long time. Additionally, when I was learning photography it was film based, so I would previsualize my image, take the shot, then process and print the film. The time between the exposure and the results was quite long. (Yes, we had Polaroid to help, but it was still important to be able to visualize and make the images I wanted.) Fortunately, with the compressed time-frame digital capture has afforded photographers, the process of visualizing, shooting, and reviewing can now be nearly instantaneous. As a result, the learning curve can be greatly compressed.

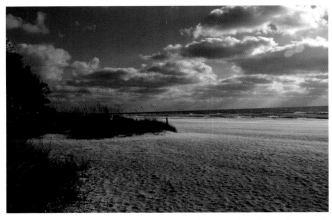

IMAGE 2-1. I wanted to photograph Rio on the beach with a surfboard. She is a surfer, and I loved the idea of *not* having her in an all-too-cliché bikini for this session. I saw the final shot in my head as soon as I saw this preliminary capture.

IMAGE 2-2. I moved in a bit to make sure I had the little sandy hill with the post on it. I wanted to use that area as a point of relationship with her and the board. I felt it would give the images a sense of place.

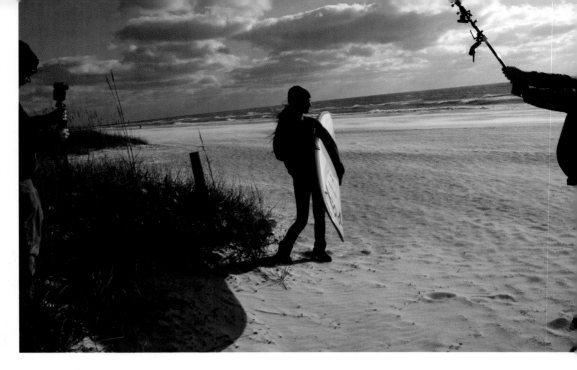

IMAGE 2-3. Next, I put Rio into position and started to light her with a speedlight in a softbox. Initially, this was on a boom, but the wind was too strong, so it ended up being held by my friend Billy. I shot from the angle required to bring the sky and sand to prominence and put Rio in the "place" of the beach.

IMAGE 2-4. The light in front of Rio seems to come from the direction of the sea. A second speedlight to camera left added light on the plants and created a small separation accent on her right side. I overpowered the ambient light by 1 stop to keep her as the focus of the composition.

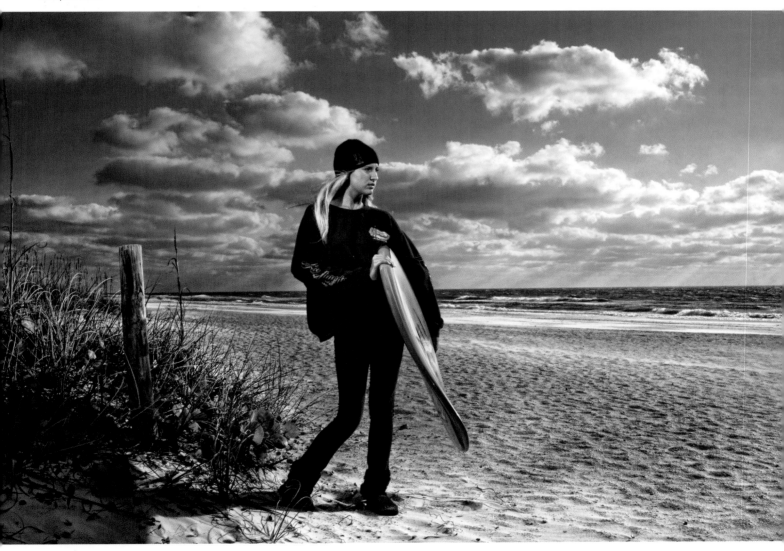

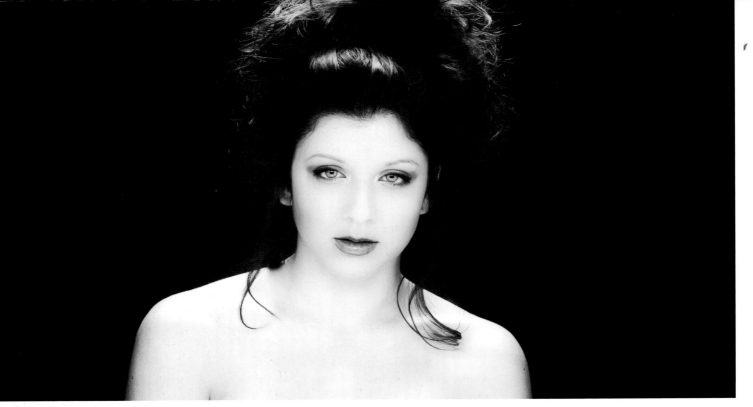

IMAGE 2-5. I knew I wanted this shot as soon as I saw Briana's hair. With a black background and her light skin tone, I knew the final look would be dramatic. I could see the print in my head before I started shooting and *knew* that it was going to be black & white. To create the soft, smooth look I envisioned I used a lot of light. For the main light, I placed a small softbox on a boom directly over the camera. A white card was paced just out of frame below her face for fill, and a zebra umbrella on a boom was positioned directly over her head to create highlights on her hair and shoulders. This was positioned back far enough back to not cast light on the bridge of her nose or forehead.

I have a checklist that may help in the visualization of the finished image in your head. As you prepare for a session, run through these important questions:

1. **What do I want to accomplish with the photograph?** Do I want to reveal an emotion? Is it a metaphorical image—do I want to tell a story or illustrate an idea? Is it simply the beauty of the subject I want to portray? Or do I want to make a portrait that reveals something about the subject?

2. **What should the final image look like?** Will it be in color? Will it have texture? Or a muted color palette? How will contrast in the image be portrayed?

3. **What should the lighting look like?** Should it be soft or hard? Should it come from one source or multiple sources? How do I want it to look in the final print?

4. **What will I do in Photoshop to enhance the image?** In order to achieve the print I have in mind, what must I capture in-camera before taking the image into Photoshop?

Yes, this sounds like a lot of stuff, but once you become accustomed to thinking this way it will all happen in a split second. Try this at every shoot. Before you start, take some time to think about what the image is going to look like. Then work toward that goal with your shoot. It may be difficult at first, but as you continue to do it, the images will start to make more and more sense to you. Do this and your photography will improve, I promise.

SUBJECT-CENTRIC PREVISUALIZATION

As I stated at the beginning of chapter 1, instead of asking what lights to use, we should be asking ourselves, "What should the subject look like in the image I'm

planning?" The answer to that question will reveal the correct lighting to use. The subject is what renders the light, so being able to visualize how you want the subject to look in the final print will dictate how you should light it.

For example, when preparing to photograph a person, I look at the wardrobe, the skin, the hair, and anything that could be effective in rendering the light in a specific way. Shiny leather or satin clothes, for example, will render the light source absolutely. With soft fabrics, like cotton and denim, the light will be somewhat reflected, but mostly in the highlight area. Fur, black clothes, and very soft materials will probably not reflect much light at all.

Skin tone is also a consideration. Smooth, glossy areas will definitely reflect the light source in any highlight area. The tip of the nose, the cheekbone highlights, and the forehead can be problem areas, as can the top of the lip and the chin. Adding matte makeup or powder helps mitigate this highlight challenge. But if the model starts to sweat—err, *perspire*—the shine will return quickly as the matte now turns glossy from the moisture. Additionally, highlights will seem much more pronounced on darker skin tones than on lighter complexions. The value of the highlights actually remains pretty much the same, but the deeper coloration of the non-highlight areas will make them seem brighter.

SAMPLE SHOOT: Michaila in the Desert. My daughter is a skater in Phoenix, AZ—not a particularly cold clime, but a great skating town nonetheless. I wanted to create an image that played off the skating attire and the desert (**image 2-6**). So on a cold Saturday afternoon (I think we were down in the low 80s) we headed out to an area south of Phoenix to make this shot. I had seen

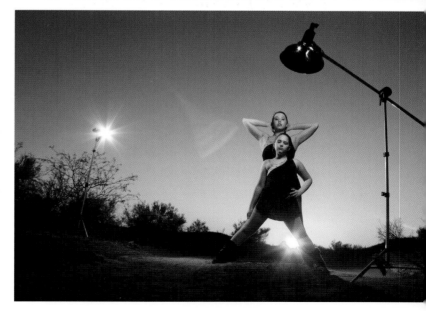

IMAGE 2-6. A home-made beauty dish was used for the main light. A second speedlight added edge lighting.

IMAGE 2-7. This shot of my daughters (that's Alissa standing in front of Michaila) shows the use of the lights. Both girls are wonderful ice skaters.

the road and knew that it headed straight for the setting winter sun, so getting there was easy.

I had Michaila enter the scene from behind to keep the sand in front of her reasonably untouched and clean. Setting suns like this are usually going to look pretty good at about f/11 and ¹⁄₁₀₀ second at ISO 100, but I wanted to get my lights back a bit, so I chose to shoot at f/8 and ¹⁄₂₀₀ second so the flashes wouldn't have to work as hard (meaning better recycle times).

I used a small, home-made "beauty dish" (thanks Megan!) with a speedlight as the main light. A second speedlight on a stand added edge light. I love the way some backlights can add to the light around the feet so I aimed the second light at Michaila's midsection, keeping the light robust around her dark legs and the sandy surface. Waiting until the sun was just on the horizon, I made the final image Crouching down low in the sand added some perspective; the tracks in the dirt road added texture and context.

SAMPLE SHOOT: Briana at the Beach. When I was previsualizing **image 2-8**, I knew that I wanted to create a desaturated look and add texture to the image in post-production. Shooting on an overcast day, the bright white sand of Anna Maria Island, FL, bounced a lot of light onto Briana's face. I added a bare speedlight on a stand behind her and shining down to simulate the look of direct sunlight and shot the image at f/8 at ¹⁄₁₆₀ second and ISO 100. I used my old Canon L 70–200mm zoom at about 125mm to get the angle and depth of field that I wanted. The final texture and color were added later in Photoshop.

A SUBJECT-CENTRIC APPROACH TO PORTRAITURE

Business portraits, fashion photography, editorial portraits, wedding photography, baby portraits, and senior photography—they are all different, but they also have one thing in common: people. People are fascinating, wondrous, challenging, exciting, and sometimes a bit terrifying. The fact that the camera can capture it all makes people one of the most widely shot subjects for both amateur and professional photographers.

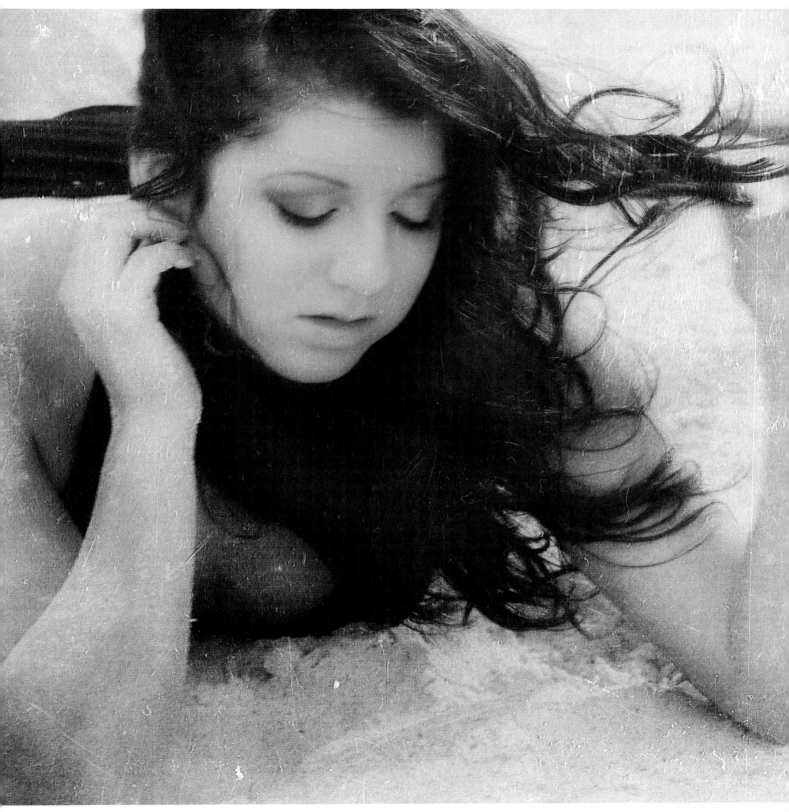

IMAGE 2-8. Knowing that I wanted to add texture to this image in postproduction allowed me to design a shoot that produced the raw materials I needed.

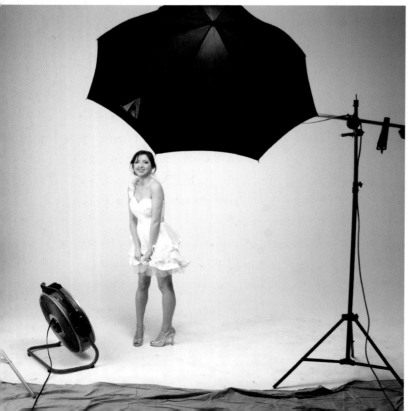

While the sheer variety of styles you might be called on to reflect in your people pictures (the stories you might want to tell about your subjects) is reason enough to adopt a subject-centric approach, there are additional reasons to adopt this approach. First, people come in all colors, sizes, ages, and shapes. Some have few notions of what they should look like in an image; others have absolute expectations about their images. (And you had better take heed of their wishes; while light interacts with people in the same ways as it interacts with everything else, most other "things" can't express deep displeasure at their faces being rendered with too much . . . well, let's say "texture.") The nuanced faces and bodies we photograph require an equally nuanced approach if they are to be rendered in a flattering manner—or, in some cases, in order to tell the story that the assignment requires.

It should be noted that this has implications beyond simply satisfying your creativity and soothing your client's ego. As humans, we are all making a seamless journey through time that alters our appearance with imperceptible subtlety. Slowly and steadily, we change and become different. Portraits allow us to liberate ourselves from this relentless march. In a fraction of a second, moments of our lives are captured in a form that will remain constant even as everything else keeps changing. Through photography, we cheat time.

By previsualizing the results you want to achieve, then thinking through the lighting tools you could use to achieving them with the subject at hand, you can work out a strategy before you even begin setting up the gear.

SAMPLE SHOOT: A Soft Look. Large umbrellas in bounce position are one of my favorite sources. In the setup shot (**image 2-8**) you can see the single large umbrella I used to make the final shot of Haley on a cy-

IMAGE 2-8 (BOTTOM). To create wraparound lighting on Haley, I chose a large umbrella in the bounce position.

IMAGE 2-9 (TOP). The final image of Haley.

IMAGE 2-10 (RIGHT). Hard light from bare or nearly bare small flash heads gave this portrait of Briana the hard edge I wanted.

IMAGE 2-11 (BELOW). The setup I used for hard-light portraits of Briana.

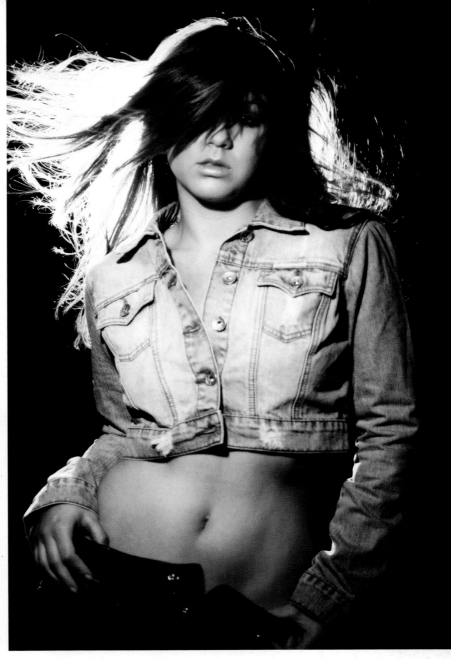

cloramic background (**image 2-9**). The large umbrella literally wraps the light behind her, leaving very little to no shadow on the floor.

SAMPLE SHOOT: A Harder Look. By contrast, the shot of Briana (**image 2-10**) was done with a small flash setup, giving the image a lot of contrast and more of an edge. I used the reflector off an old Sunpack strobe pushed into an old Gary Fong diffuser to create a round light source for the front light. It was aimed right at her face from only a slight angle over the lens axis. The backlight came from a bare strobe directed back at her head. I also

set up a wind machine to blow her hair forward (instead of the usual backward direction).

During the session, I would shoot with no idea as to whether the flare would be too much until it came up on the tethered laptop screen. As you can imagine, we did lots of images to get it just right. Fortunately, the power on the flash units was quite low, so the recycle time was nearly instantaneous.

SAMPLE SHOOT: Highlights for Contouring. In my portrait of Desean (**image 2-12**), I wanted to accentuate his chiseled features and physique. As you can see,

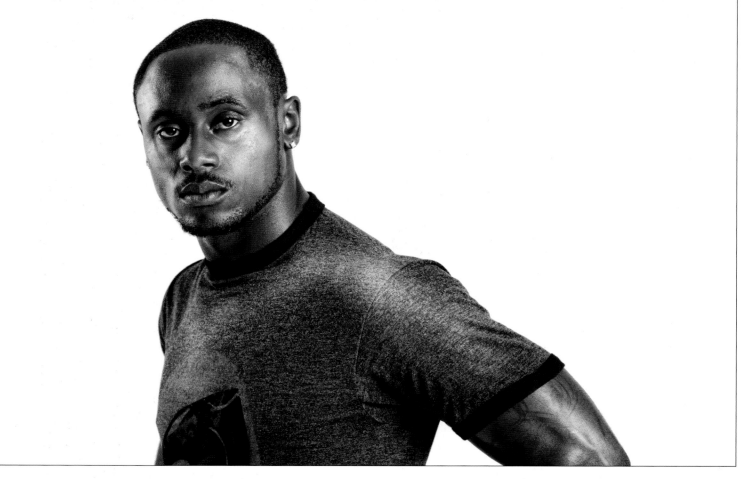

IMAGE 2-12 (ABOVE). To accentuate Desean's sculpted features and physique, highlights were created on his dark complexion.

IMAGE 2-13 (FACING PAGE). To create visible highlights, Richelle was photographed with wet skin. The light reflected from the slick surface presented a far more carved look in the highlights than we would otherwise see on her fair complexion.

IMAGE 2-14 (LEFT). In this shot of Briana, you see very little specular highlighting on her face. Her pale skin, made matte with powder, does indeed reflect the sources of light, but they do not stand out as dramatically as in the shots of Richelle and Desean.

it is the highlights on his face and arm that accomplish this. These highlights are direct specular reflections of the light sources: one large umbrella and one medium umbrella. Because Desean has a darker complexion, the highlights stand out prominently. To create the same contouring for a subject with a fair complexion, I would have used shadows—darker tones that would contrast better against light skin.

SAMPLE SHOOT: Balancing Hard and Soft. After photographing Stephanie surrounded by wood carvings, the sculptor asked if she wanted to hold the chainsaw—and she jumped at the idea (although she was disappointed to learn she wasn't going to get a chance to unleash that bad boy on a couple of logs!). I loved the idea of putting the camper in the background, so I brought her into a

IMAGE 2-15. Combining hard and soft light sources with the ambient light were critical to designing this powerful yet flattering image of Stephanie.

space that would accentuate her in the final composition. To design the image I previsualized, I needed to create powerful but flattering light on Stephanie's face while accentuating both the chainsaw and the unique environment around her.

Adding a strobe on a boom and bringing it over her face from camera left gave me wonderful light on her face. I used a medium softbox with a diffuser cap on the strobe itself for a very soft main light. (*Note:* The diffuser cap makes the light spread all through the softbox and eliminates the hot spot that is so often a result of using a bare strobe.) I then added a smooth, shiny white fill board on her shadow side to open the shadows a bit. Bringing the light in very close to her produced nice, soft lighting that wrapped around her face and also bounced off the fill board nicely. This meant the shadow side of the face had a lot less contrast than it would have without the fill board. To separate her from the background, a bare strobe was added to camera right and set to match the main light. It was placed at a lower angle to make sure it caught the edges of the chainsaw.

We then had to wait for the sun to come out from behind the clouds. As soon as that happened we had a minute or two to get the shot (**image 2-15**). I underexposed the ambient light about a stop to make her pop, and the great backlight across the sawdust really makes the shot.

PRACTICE ASSIGNMENTS

PRACTICE ASSIGNMENT: Soft Beauty Image. Let's contemplate an assignment. For this shot, you'll be creating an image of a model. The image will be printed quite large with some product around her. The client has

IMAGE 2-16. This tight shot of Lynne was created using a beauty dish from the right. This was placed very close to her. A medium softbox was added over her shoulder. I kept the light equal from the softbox and the beauty dish. I also surrounded the front of the model with white cards. This provided bright, soft light with some punch from the front beauty dish. The exposure was f/9 at $^1/_{60}$ second at ISO 100. The light was even from front to back.

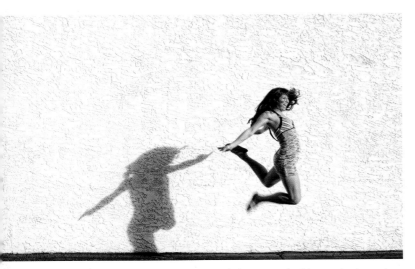

IMAGE 2-17. I love dancers and skaters and athletes who know how to give their all in front of a camera. I saw this shadow happening on the wall and thought it might be kind of cool to have the shadow and Briana jumping together. I like how it broke up the large white space and has seemingly no connection to her. This is pure, late-evening, winter sun in Phoenix.

IMAGE 2-18. This shot was taken right after the jumping shot. I wanted to move in and split Briana with the light. I cropped very tight to create a more dynamic feeling—one that seems to have her pulling out of the frame. Her expression ties it all together.

shown you some images that she likes, and now you must shoot something that will fit her expectations.

Given that you have some sample images to study, it should be easy to make some master decisions fairly instantly. So let's say you notice that the images all have soft light and very smooth highlight-to-shadow transitions. You also notice that there is a difference in the light from the lit side to the shadow side (which is to say, the lighting is not flat). Looking at the samples, you should be able to determine approximately where that ratio lies.

Based on these observations, you'll know that you can leave your hard-light tools (like snoots and direct reflectors) in the box. This shot requires soft light, so a large light source will be needed. You'll also need some light source to fill the shadow side of the face and provide the desired ratio. How exactly you achieve that light will be up to you—based your style, the tools you like to use, how you prefer to work, and more.

PRACTICE ASSIGNMENT: Portrait with Long Shadows. Here's another scenario to consider. You are watching a group of dancers at a street fair and notice long shadows on the wall caused by the low setting sun. This triggers an idea for a shoot with a model. How would you choose the appropriate tools to make that happen? (Hint: You will probably not want to use big scrims and softboxes in close. With those tools, the subject would be wrapped in light, so the desired long shadow would not be produced.) Consciously undertaking this kind of thought process is how you get to the point of being able to create the effects that you see in the world around you—and in your mind's eye.

PRACTICE ASSIGNMENT: Smooth Skin, Textured Fur. When working with textures like fur, you will have to create a very bright source for the edges to reflect. There are two primary ways to approach this: either by using a point source (like a grid spot), or by bringing in a soft light source and using it very close. For fill, I will either use something very bright (like a shiny white board) or something very strong (like a silver bounce card). The darker the fur, the more fill will be needed. Occasionally

IMAGE 2-19 (LEFT). Michalia in fur. A small zebra umbrella created backlighting to show the texture of the hat. IMAGE 2-20 (RIGHT). Christina in fur. A small light placed close to the subject helped reveal the soft texture of the jacket.

I will use a second light source, such as a grid spot or snoot. More often I will bring in a smaller source, quite close to the subject, for more contrast in the fur.

Let's look at two examples. In the first image (**image 2-19**), Michaila was wearing a fur cap that I wanted to show off. In addition, the leather jacket had some wonderful texture that I wanted to reveal. I used a 4x6-foot softbox to reveal the texture of the leather, as well as to provide wonderfully soft lighting on the face. Bringing in a fill card to just outside of the frame provided enough fill to open the shadows and add light to the fur on the shadow side of the subject.

To show the fur as soft and having lots of soft texture, I added a small silver/white zebra umbrella from behind the model. I was very careful to keep the light far enough back to not hit her nose—just forward enough to drop the light down across the fur on her hat.

For the image of Christina (**image 2-20**), I used a 2x2-foot softbox in very close to her from camera right. The light was less than three feet away from her, producing a very bright light with rapid fall-off. Since I was going for a shot with a lot of contrast, the small source was used without any fill to camera left. I added a small silver umbrella behind her to for some backlight touches on the fur, showing the edges of the fur to the far back right. That, and the very bright specular reflections from the small softbox in front, was enough to communicate the soft texture of the fur coat.

3. CONTROLLING THE LIGHT

Now that we've looked at (and theorized about) many of the ways in which we might need to implement light, let's take a step back and consider the most basic tools at our disposal: the qualities of light we can control to make our subjects look the way we want them to.

Light has four main qualities that we have to understand and deal with as photographers. Even though I've presented them in a specific order in this book, they are all equally important—and so incredibly intertwined that it would be a mistake to approach them using any kind of rigid sequence. (The only exception would be the color of the light, which is something you'll almost always make early decisions about in your lighting-design process.)

In order to work quickly and fluidly through your session, you'll need to keep all of these four controls in mind and work within the structures they present.

1. THE COLOR OF THE LIGHT

Light has an inherent color temperature that will affect the way the colors in your scene and subject are recorded by the camera. For example, morning light is generally much warmer than midday light. Fluorescent lights in offices have a different color temperature (more green in color) than the incandescent lights in our household lamps (more orange in color). Overcast skies yield a different color of light than clear, sunny days. I could go on and on, but you're getting the picture, right? Light has color associated with it. That color matters to us—and it can matter a great deal when we start to mix the types of light and try to get a cohesive color in our images. For instance, combining tungsten light (orange) and fluorescent light (green) can produce strange results.

White Balance Setting. Happily, shooting RAW gives me *all* the colors in the scene and I can adjust them to a pleasing color balance later. I simply choose a white balance on the camera that most looks like what I want the images to look like in final production. If necessary, I can use the RAW file converter to adjust this after the fact—but during the shoot, having the images pop up on my tethered laptop in the color space I want makes it much easier to achieve the final photograph I have previsualized.

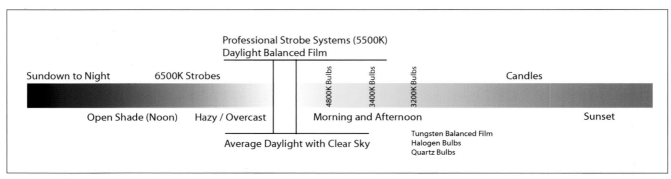

IMAGE 3-1. Chart of color temperatures.

I generally do not shoot using the automatic white balance setting because it allows the camera to make decisions based on the light in the scene. This could result in a difference color balance from image to image as I move around the set—and that is not acceptable to me. I want all of the images to match each other so that I can make any needed color adjustment to one image and then apply the same adjustment to all the other images of that set. To do that, the color balance setting must be identical in each frame—no matter where I am shooting from.

Now, keep in mind that I am coming from a commercial photography background, so not a lot of changes happen within a given setup that would necessitate me changing any settings. I find a scene, place my subject in it, and spend from ten minutes to several hours preparing for the photograph I am going to make in that scene. Exactness and repeatability are very important to my way of working. If I were a photojournalist, or a wedding photographer, or shooting travel images—genres in which the scenes and situations can vary widely from shot to shot—I might approach white balance a bit differently.

Filters for Mixed Lighting. Postproduction color-balance corrections to RAW files works great—unless there are mixed light sources in the scene. When this is the case, correcting for one color may throw the other colors out of their normal range. When this happens, you may need to filter one or more of the light sources to bring the colors into balance.

PRACTICE ASSIGNMENT: Sunset Portrait. For example, imagine you are photographing a swimsuit model on the beach at sunset and decide to add a portable strobe as a main light against the setting sun. Unfortunately, the light from the strobe is not the same color as the light of the setting sun; it is cooler in temperature. Sure, you could correct for this after the fact by adding more warmth to the entire image to warm her skin color up, but that would also warming up the rest of the image. Besides—this is a lighting book, so let's work on getting it right in the camera.

SHOOTING JPEG: THERE *IS* A CASE FOR IT

When shooting something in a very tightly controlled lighting situation, I can shoot JPEG with a good feeling of confidence—meaning that I know I won't need to do much color editing or heavy lifting in postproduction. Shooting JPEG simply doesn't allow me to do as much with the image as I can do with RAW, but sometimes I don't need to do that much with it anyway.

To me, shooting JPEGs is like shooting slide film. The film goes into the camera and is exposed to very exacting tolerances of exposure. Slide film doesn't have much leeway for error. After the film is developed, it is given back as a color transparency; therefore, the film itself is the final product. As a result, if you missed the exposure, you missed it. There isn't really much else you can do with that piece of exposed film.

Shooting RAW is more like shooting negative film; there are many more options—paper choice, contrast, developer chemistry, burning and dodging, and even more radical tools. The print can be manipulated in many wonderful ways without altering the negative. We can even bring that negative back into the darkroom and make new prints with totally different tonalities, contrasts, and emotional appeal without altering the negative.

The JPEG is like a slide: shoot it perfectly and be happy with what you get. The RAW file is like a negative: bring it back into the digital darkroom again and again to create new and different images. Also, as your postprocessing acumen grows, RAW files from earlier in your career can be reprocessed for different—many times better—looks.

The solution is to warm the light from the strobe. Adding a bit of a orange will render a closer color temperature to the setting sun. I would recommend a ¼ CTO filter for earlier in the sunset hours; if the sun is quite red, a ½ CTO filter may be needed.

The same thing can happen when combining tungsten and fluorescent lighting or daylight and tungsten lighting. At some point, you must correct one of the

IMAGE 3-2 (LEFT). This image of Briana was taken very early in the morning in Mexico. The morning light is a bit cooler than the late afternoon light, so the strobes I used for fill from camera right did not need to be modified. The cool light of the strobe is similar in color to the very early morning light.

IMAGE 3-3 (FACING PAGE). This shot of Briana was taken late in the day. It is a warm, comfortable light for skin tones. I didn't alter the color, but let it stand to give the shot a feeling of the warmth that I saw in the viewfinder.

variables at the source in order to maintain an even color balance in the light reaching your sensor—and minimize the time you spend sitting in front of a monitor correcting images with dozens of masks.

When I am photographing people, I am aware of the color of the entire scene and make adjustments to the image based on what I want to emphasize. Since I am shooting RAW, it is very easy to color correct the entire image when I get it into the conversion software, but secondary light colors must be dealt with on set.

I carry a full set of color gels with my speedlights, and a more basic kit of gels for the big lights. The ¼ CTO, ½ CTO, and slight blue gels are the ones I reach for most of the time. Usually, I either want to warm my lights to the surrounding warm ambient light or cool them for a special effect. I carry gels for fluorescent and tungsten as well, but only on the more commercial jobs. (My personal and portrait work is rarely dependent on highly precise color matching.)

SAMPLE SHOOT: Katherine at Sunset. I was looking for a good sunset background—and I found it. To keep my main light in the same color range as the gorgeous sunset, I added a full CTO to the strobe inside the small softbox. This was an unusually cold day on the Florida beach, so the models kept warm in their poncho while we set the lights and tested to get the exposure I wanted

(**image 3-4**). I knew that the sunset would be around f/11 at $^1/_{100}$ second and ISO 100, so I did a test at that setting and saw that it was a bit bright.

For the final image of Katherine (**image 3-5**), I cut the shutter speed down to $^1/_{160}$ second (dropping the exposure by $^2/_3$ stop) to darken the sky and the sunlight. Katherine was lit at close range with a softbox that was warmed with a $^1/_4$ CTO filter. I added a speedlight (also with a CTO on it) to the back of the subject and made sure that a little bit of it spilled onto her cheek. It was set just a little over the front light, giving the impression that the sunlight was spilling onto her as a natural back-light would do. While I had a *real* natural backlight, it wasn't actually doing enough on her to "feel" like a backlight.

IMAGE 3-4 (LEFT). The test shot revealed that the exposure was a bit bright.

IMAGE 3-5 (BELOW). The main light and backlight were each fitted with $^1/_4$ CTO gels, making the otherwise bluish strobes match the color of the sunset lighting.

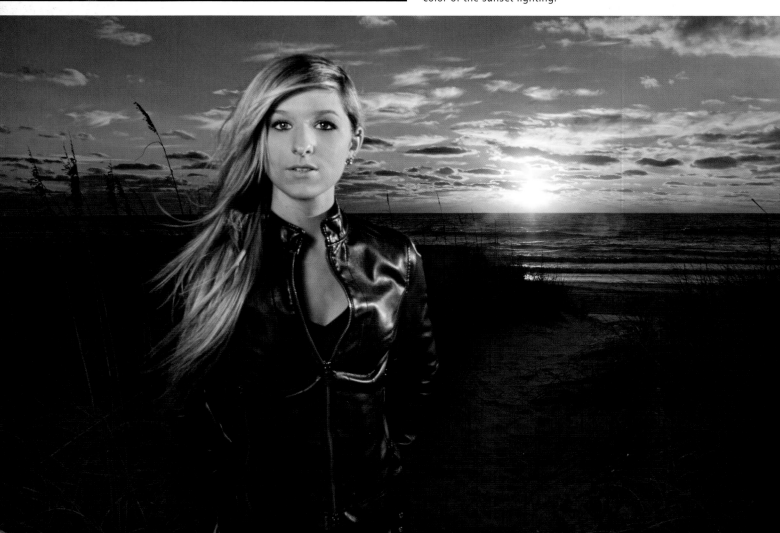

IMAGE 3-6. The sun is huge, but it is so far from us here on Earth that it functions as a very small light source and produces very sharp shadows. When the source is so much smaller than the subject, the subject completely blocks the light, becoming almost like a flag or a cookie, to provide a sharp-edged shadow. Here, Lynne was photographed in the alley behind my studio where the harsh sunlight produced sharp shadows behind her—and added a ton of texture to the brick wall. Small, sharp light sources can be very powerful tools when you want to show texture.

2. THE SIZE OF THE LIGHT

The size of the light source makes a huge difference in the way the subject is rendered; large sources produce softer lighting while smaller sources produce harder lighting. It is important to note, however, that the effective size of a light source can only be determined in relation to the subject. It has nothing to do with how big the light is compared to other light sources.

This can be confusing because photographers often describe an umbrella as being "medium" or "large." That designation is for choosing from within the domain of umbrellas. A 60-inch umbrella is a large umbrella when compared to a 43-inch (medium) umbrella or a 33-inch (small) umbrella. However, until we apply that particular umbrella to a subject, we haven't really discovered if it functions a large or a small light source. For instance, a 60-inch umbrella in close to a subject's face will be a very large light source. Because of the modifier's immense mass in relation to the subject's head, the light may wrap all the way around the face for a very soft look with extremely gentle shadows. However, if that same 60-inch umbrella was placed 30 feet from the subject it would a lot smaller in relation to the subject. The resulting light would be much harsher with

IMAGE 3-7 (ABOVE). This image shows Michaila lit with a small reflector. Notice the sharp shadow line and how it lays against the wall.

IMAGE 3-8 (LEFT). This image, also created with a small reflector, shows how harder light can be used to our advantage. The shadow becomes a big part of the image.

IMAGE 3-9 (ABOVE). A medium reflector still delivers a defined shadow, but the edges are now softer and the shadow is not as dark as it was in the small reflector shot.

IMAGE 3-10 (LEFT). This look, also created with a medium reflector, is one that I like a lot. It has a kind of natural look—like direct sun. Again, it is a very popular lighting style among editorial and fashion shooters.

IMAGE 3-11 (ABOVE). Switching to a large umbrella kills the shadow almost completely because the large source sends light behind the subject and onto the wall.

IMAGE 3-12 (RIGHT). This lighting (from a large, white satin umbrella) is considered soft and directional.

darker, more dramatic shadows. At this distance, even a physically large source is effectively small; the light from it will not wrap around the subject and will only be seen on the lit side of the face.

As you are preparing to make a photograph, you need to see in your mind's eye how the subject will be affected by the size of the light source. Do you envision deep, defined shadows? Or softly breaking light with gentle or very faint shadows? Are the lights going to be reflected by any surface that would necessitate them being brought in closer or moved back?

The choices you make for your source will be determined, to a great degree, by your subject. While it is quite easy to shoot a single subject with a 60-inch umbrella in close, it is not possible to do the same thing with a group of twenty-five people. As you will see

throughout the rest of this chapter, size and distance are related; the farther back the light goes, the larger it may have to be to create soft lighting on the subject.

SAMPLE SHOOT: Small Light, Close to the Subject. Let's look at how this concept applies when photographing objects. I will use an ad I shot for Dimensional Software to demonstrate the effects of a small light source in very close to a subject

For **image 3-13**, the computer, whistle, and ball were all arranged on a table and I used a 24-inch softbox about two feet behind and above the set to create the light from behind. While this would actually be considered a small softbox in comparison to other softboxes, it was quite a large light source compared to the small items I was shooting. The set only measured about 18 inches square, so the softbox was more than twice as big

as my subjects. Accordingly, the reflection on the top of the computer is large, while the light falls off from the ball behind. With this one source, I got both soft, even lighting and light that seems dramatic as it falls away from the subject.

If I had pulled the same light source back, making it smaller in relation to the subjects, the areas in shadow would have been darker and more sharply defined. Additionally, the background would have been completely blocked from receiving any light. Conversely, if I had introduced a soft scrim above the subjects, the light would have become much larger in relation to the subject. Light would have come from all angles, so where there is shadow in the image shown, there would have been little or no definition.

IMAGE 3-13 (FACING PAGE). A "small" 24-inch softbox functioned as a large source (producing soft light) in relation to these small subjects.

IMAGES 3-14 AND 3-15 (BELOW AND RIGHT). Soft shadows created behind Lynne formed an integral part of the composition I envisioned for this image.

SAMPLE SHOOT: Lynne with Shadows. In these images of Lynne (**images 3-14 and 3-15**), created in the alley behind my studio, I used the shadows as a compositional element. The interplay of light and shadow gave the images some dynamic flair. Looking at the shadows, we would say this light is soft; they are softly defined and the light seems to wrap around the subject.

On a very sunny day with no clouds, the shadows would be much deeper and sharper. Again, this is be-

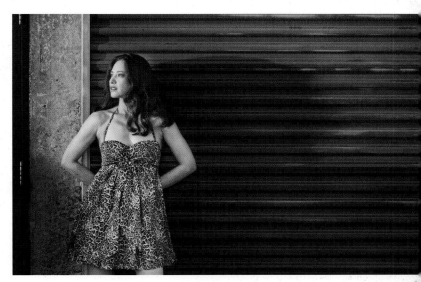

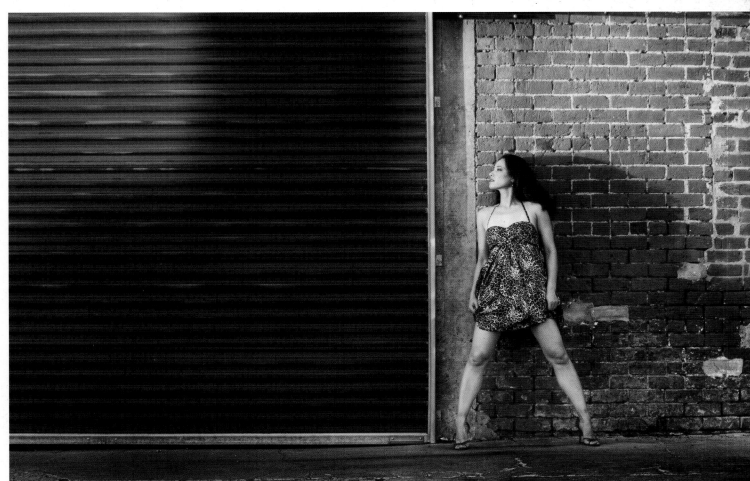

IMAGE 3-16 (FACING PAGE). Soft light from the open sky was the key to this engaging portrait of Briana.

cause the sun is effectively a very small light source—so small in relationship to the subjects here on our planet that it is easily blocked in its entirety. When this happens, the sunlight cannot penetrate the shadows, creating deep, defined shadows and very bright highlights.

SAMPLE SHOOT: Open Sky. Open sky can be a nice source of light. **Image 3-16** was taken of Briana in Chicago, where she was lit totally by natural light. Placing her at the corner of a building, I used the open sky and the lit buildings behind me to light her face. The sun was streaming down the wall behind her and she simply blocked it. Letting the edges of her hair and the area behind her blow out kept the shot warm, accessible, and very close to the way I saw it when I shot it. She is creating the shadow coming forward, and it is the placement of that shadow that makes the shot work so well.

Now, imagine that high cloud cover moved in, covering the sky from horizon to horizon. The clouds would become the light source—a *huge* light source. No matter where you are, you would see some of that light source. As a result, the light would penetrate into the area where we see shadows in this image.

SAMPLE SHOOT: Clamshell Lighting. Briana was lit with a clamshell lighting setup for **image 3-17**. Two medium umbrellas were placed vertically, with the camera in between them, to provide a very large light source on the subject. Even though Briana was posed only a few inches from the background, the light seems to wrap all the way around her. The result is almost shadowless.

SAMPLE SHOOT: Under the Trees. Katherine (**image 3-18**) stood under a group of trees near Bradenton Beach, FL. We used a 2-foot square reflector with a soft silver surface to bounce the setting sun back into her face. (*Note:* The soft silver surface is metallic but with more of a matte finish, so it doesn't produce the blinding specular light a very shiny reflector does.) My bud Billy Kidd held the reflector slightly out of frame so that the light source was effectively twice the size of her face. The resulting light is soft, even though it is from a silver

IMAGE 3-17 (LEFT). A very large light source created shadows that are so soft and light they are barely visible.

IMAGE 3-18 (RIGHT). A soft silver reflector placed close to the model's face bounced warm sunlight from the setting sun for a soft effect.

reflector. The warmth from the setting sun resulted in the ambient color.

SAMPLE SHOOT: **On the Beach.** The light source for this portrait of Briana (**image 3-19**) on Anna Maria Island, FL, was the bright white sand, which kicked back light from the overcast sky. The softness of the light as it filled her face was really beautiful. Essentially, the vast expanse of bright sand provided a massive light source. I added a speedlight from behind her, set at ½ stop over the light on her face, as a crisp hair light/backlight.

SAMPLE SHOOT: **Portrait with a Small Softbox.** To create **image 3-20**, I used a very small softbox in very close to Lynne. You can see how fast the light falls off across her chest. This light is effectively large because it was used close to her and that makes it soft, but it has even more contrast because of the close placement (read on for how distance affects this quality of the light). A hair light was added to keep her dark hair from disappearing into the background. A large fill card was also placed just below her face, toward the camera.

IMAGE 3-19 (FACING PAGE). The white sand on the beach functioned as a massive main light for this portrait of Briana.

IMAGE 3-20 (BELOW). For this portrait of Lynne, a small softbox was used close to the subject. A hair light provided separation and a fill card was used to open up the shadows below her face.

3. THE DISTANCE OF THE LIGHT

We know that the closer to the subject the light is, the larger its apparent size will be to the subject. However, there is another distance-related factor to consider: the intensity of the light and how it changes over a distance. This is described using something called the Inverse Square Law. Simply put, light goes away from the source in all directions, both vertically and horizontally. As it spreads out to cover a greater area, the light loses intensity. Fortunately, it spreads in a uniform and easily understood way: every time you double the distance between the subject and light, you quarter the intensity of the light. (Here's the math: doubling the distance gives us a value of 2, the square of 2 (2^2) is 4, and the inverse [putting a "1" over the value] of 4 is $\frac{1}{4}$.)

If you moved the main light away from the subject—say, from 3 feet back to 6 feet—you'd anticipate a significant drop in the overall light level on the subject. As noted above, the light at 6 feet will be $\frac{1}{4}$ the intensity that it was at 3 feet (half the distance). Here's what's interesting, though: when the light is placed very close to the subject (say, 1 foot away) the same drop in intensity—to $\frac{1}{4}$ of the original value—will happen over only the next 12 inches. Over those 12 inches, the lighting will drop by 2 full stops. The closer the subject is to the light, the more rapidly its intensity changes.

Even if you don't get exactly how this works, you can see the effects of it on your work. For beauty shots and portraits, I like to have the light in very close to the subject. One reason is for the size of the light source (remember: bigger light sources mean softer transitions to the shadows), but another is for how quickly the light falls off from the source and across the subject.

4. THE ANGLE OF THE LIGHT

We've all heard (and it very well may be true) that "everybody has an angle" when telling us something. In lighting, having an angle on what you want to do can make or break your shot. Lighting depends on three different angles: the angle of the camera to the subject, the angle of the subject to the light, and the angle of the

IMAGE 3-21 (FACING PAGE). The close proximity of the light creates highlights and shadows as it falls across Briana's figure on the road in California. I am using an unmodified flash unit at a very close proximity, so the difference as the light falls across her is nearly a full stop. The sun coming from over her (camera right) shoulder is then placed against the darker skin as the light falls away.

light to the camera. These angles create two big triangles: one on the vertical plane and one on the horizontal plane. (*Note:* The one exception to this is on-axis lighting, where the light, camera, and subject are positioned along a line—usually with the main light placed above the camera. In this case, the only triangle formed will be on the vertical plane.)

The Vertical Plane. On the vertical plane, the higher the light is above the subject, the more shadows will be cast downward. With the main light at a higher angle, shadows form under the eyebrow, nose, lips, and under the chin. Faces with nice cheekbones will be enhanced a great deal by this sculpting from above.

The most extreme position on the vertical axis would have the light coming straight down onto the subject, however I rarely go higher than a point where the umbrella shaft is pointing down toward the eyes of my subject. Beyond that, I consider it effect lighting. Casting shadows and creating drama and sculpting the face can be wonderful ways of working, but you must know what the subject is going to render back to you when you do.

I almost never light a subject from below the camera axis unless I want some sort of Halloween look in the image. Light coming from below is rather "old horror movie"; unless I specifically need that look, I don't go there.

The Horizontal Plane. On the horizontal plane, the greater the angle between the subject and the light, the more shadow will be created by the light on the subject. So what's the right angle?

I read so many things about photography that make me scratch my head. Some things seem almost comical; some are not well thought out. It is often suggested that you put the main light at a 45 degree angle from

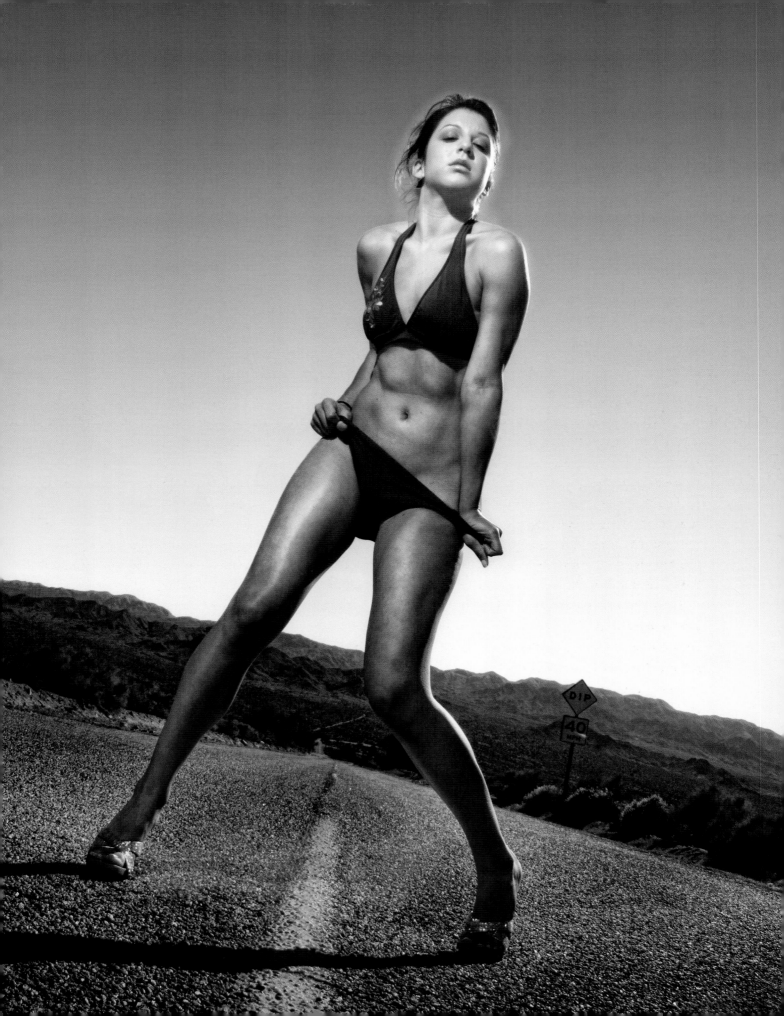

CHANGING THE VERTICAL PLANE

These images were shot without any added fill light to show the complexity of the definition on the face we can achieve just by increasing the height of the main light relative to the subject. The subject reflects the light back to us in a much different way as we raise the height of this primary light source. By positioning it carefully, we can sculpt the face by using its natural three-dimensional qualities to create shadows, areas where the light cannot be seen.

Amber Lee (**image 3-22**) was lit using a small shoot-through umbrella placed on a boom. This was positioned right above her face and angled down to illuminate not only her face, but also her red dress. This same light also spilled onto the small area around the doorway. A second strobe was brought in from camera right to throw some light onto the plants and the edge of the concrete slab. Diffuse sunlight behind her provided slight backlighting.

IMAGE 3-22. Amber Lee was lit by a small shoot-through umbrella on a boom right above her face and angled down.

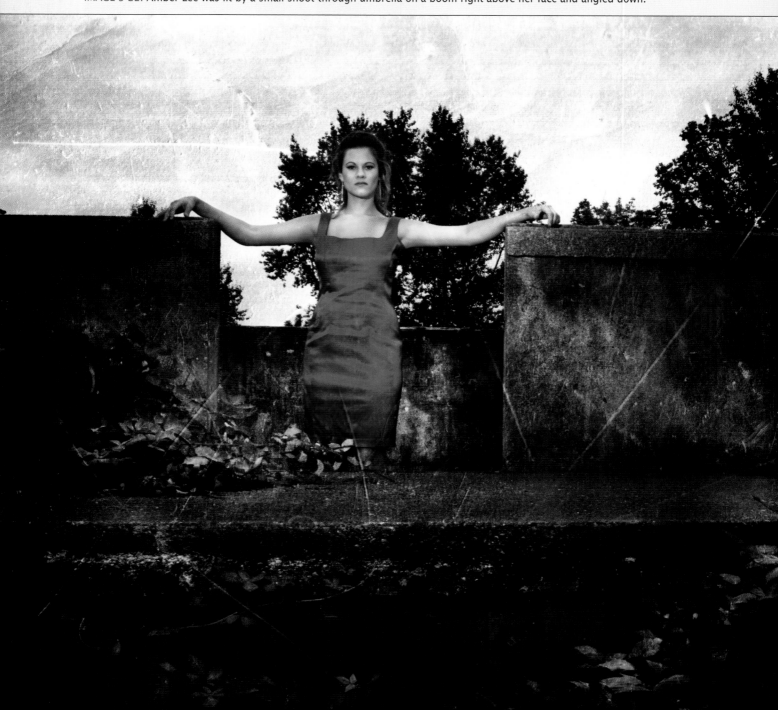

The portrait of my daughter (**image 3-23**) was created under the canopy of a tree, where the ambient was quite dark; f/4 at $^1/_{100}$ second at ISO 400 is quite dim light for my work. For the main light, I used a speedlight in a small softbox to camera right and placed about 7 feet from my subject. It was just above her eye level. A second speedlight behind made the back of her hair glow. The result is a cinematic effect that looks a bit like a fantasy.

One of the nice things about using speedlights in dim situations is that they suddenly seem to have a lot of power. The softbox light was at $^1/_{16}$ power and the backlight was dialed down to $^1/_{32}$ power. The recycle time was no problem in this situation.

IMAGE 3-23. For this portrait of my daughter, a speedlight was placed just above her eye level to camera right.

IMAGE 3-24. Alissa is looking straight into the light, which was slightly off-axis to camera right. (The umbrella was placed next to the camera and I shot with my lens actually touching the edge of it. Since it was a large umbrella, the light reads as coming from camera right.) No fill was added.

IMAGE 3-25. Here, the light on her face has moved to a 45 degree angle.

IMAGE 3-26. Now the light is moved to nearly a 90 degree angle to her face, producing sidelighting.

the subject. To me, this approach doesn't give enough consideration to the subject. We are about subject-centric lighting here, and putting the light at a 45 degree angle by default is putting the light before the subject. We want to put the subject before the light, not just arbitrarily place it to make an exposure. We want to use the light and its values to produce the shots we have previsualized.

Let's look at a few images with the light source at different angles to the subject, working from on-axis lighting to side lighting. (*Note:* Generally, when the light moves beyond a 90 degree angle to the subject it is no longer considered a main light; it becomes an accent light, rim light, or backlight.) For these shots (**images 3-24, 3-25, and 3-26**), I did not have the subject turn with the light; she is looking straight at the camera for an "apples to apples" comparison.

Next, let's examine a sequence of images showing how we can work with the model in the chosen light to make cool photographs. Here, when the angle of the light changed, I also changed the angle of the subject's face. By doing this, I used the way the light worked on the subject to produce a different "feel" in each of the images. As you can see, the subject's relationship to the light is imperative and you should build your lighting setups accordingly.

To create these **images 3-27, 3-28, 3-29, and 3-30**, I used a single 43-inch Profoto white umbrella with no fill. By moving the subject's face to render the light, however, I made images that look strikingly different from each other.

IMAGE 3-27. With the light at an oblique angle to the camera, I turned Alissa to have the light on the mask of her face.

IMAGE 3-28. I brought the light forward, toward the camera, and moved Alissa's face toward the camera to match the angle.

IMAGE 3-29. With the light at a 45 degree angle, I had Alissa look straight into the camera again.

IMAGE 3-30. Finally we end up with the light near the camera–subject axis.

4. LIGHTING TOOLS

Photographers each have their favorite light modifiers and I am no exception. Let's take a look at some of the tools we can use to make our lights do more things and provide a variety of lighting effects on our subjects.

REFLECTORS

Most lights are shipped with some sort of reflector. These slightly parabolic tools force the light forward and keep it from spreading away from the bulb or flash tube. They are very directional and in most cases are not very big. They can help increase the power of the light and they can provide an interesting small light source, as well. I tend to use the edge of these reflectors to shape the fall-off on my subject. These reflectors are also used in umbrellas to keep the light from spreading too wide and blowing past the umbrella itself.

UMBRELLAS

I love umbrellas and own over twenty-five of them—in all shapes, and kinds, and sizes. There are basically three different kinds of umbrellas: shoot-through, bounce, and parabolic.

Shoot-Through Umbrellas. A shoot-through umbrella is one that allows the light to pass through the umbrella's white fabric. The light source is aimed at the subject and the umbrella is placed between the light and the subject. The shoot-through umbrella instantly does two things to the light. First, it spreads the light out into a much larger source. Second, it diffuses the direct light, scattering it widely. As the light spreads out, it produces a slightly brighter area at the center of the um-

IMAGE 4-1. Jazmin is in front of a medium umbrella that was placed just above the camera and on-axis with the lens. Just out of view, I placed a large fill card to produce a clamshell configuration. If you look carefully at her eyes, you'll see the reflection of the umbrella and the card. This very bright "wall of light" created cool highlights on her shiny jacket. The light filled in under her chin and wrapped around her. In addition to the umbrella and fill card, I placed a 36-inch zebra umbrella over and slightly behind her for a hair/shoulder light. This was tilted forward but placed back far enough to not spill any light onto the bridge of her nose. It was set to the same exposure as the umbrella in the front.

IMAGE 4-2 (RIGHT). This is Richelle with a shoot-through setup in the studio. I placed a large piece of white seamless to camera left to help gather some of the escaping light and provide a secondary large panel of light. There was a second speedlight against the wall behind her, providing a very slight spray of light. A third speedlight above her was aimed at the back of her shoulders and hair. It was set to the same strength as the main shoot-through umbrella. The reason it seems a bit brighter is that some of it bounced off her hair and right into the lens. The same thing happened at the edges of her shoulders.

IMAGE 4-3 (TOP LEFT). Here is a resulting image of Richelle using the setup shown. You can see the subtle spray light and how the hair light is there, but not with an overblown "glamour" look.

IMAGE 4-4 (TOP RIGHT). In this shot, you can see how the light from the umbrella hit her face for a soft look. The direct hair light swept across her chest providing strong highlights and a feeling of two distinct light sources. This is one way of creating a dramatic feeling in a photograph.

SHOOT-THROUGH *vs.* BOUNCE UMBRELLAS

IMAGES 4-5 AND 4-6. The setup image shows a bounce umbrella used with a speedlight in an ambient light situation. I placed a fill card close to Briana, along with another speedlight on a stand for an accent on her hair. (The setting sun was behind her, but not bright enough to create a hair light.) In the resulting image, notice how the light wraps around her face and creates an even, soft look. The very close light and the bright fill on the shadow side is great lighting for beauty images.

IMAGES 4-7 AND 4-8. In the setup image, you can see we have the same backlight and fill card, but now with a shoot-through umbrella. The resulting look is similar—but the difference is significant enough that the two sources could not be considered interchangeable. Notice how the model's face now has more modeling on it. This is because of the light pattern from the shoot-through umbrella; as the parabolic shape turns away from the face the light from that area becomes a bit less powerful.

brella with a gentle fall-off as the modifier bends back away from the subject.

Bounce Umbrellas. Umbrellas in the bounce position have the light source turned away from the subject and toward the inside of the umbrella. The light then fills the inside of the umbrella and is bounced back out the front of it. Bounce umbrellas offer a less gentle degree of fall-off than shoot-through umbrellas and the light is more concentrated toward the center of the umbrella.

Most of my umbrellas are black-backed bounce umbrellas for a simple reason: many times they are placed in front of the camera position. Without the black backing, they would spill light into my lens, causing lens flare. The black back keeps the light going where I want it to go. It also prevents light from spilling off into the studio or the set, creating highlights I may not want. In short, the black-backed umbrellas give me the most control.

While the exterior of bounce umbrellas are black to prevent spill, the interiors come in many flavors: matte white, satin white, silver, gold, and zebra (with alternating white panels and gold/silver panels). Silver and gold umbrellas have metallic finishes, so every tiny speck of metal in that fabric creates a tiny specular highlight. That can wreak havoc on a face or be the most beautiful light on a background. White umbrellas, on the other hand, create light that is more diffuse in nature. They are a softer source that renders the skin with less contrast and far fewer specular highlights on cheekbones, noses, and eyebrows. I use white umbrellas on people, but opt for metallic umbrellas when lighting backgrounds, when bouncing light onto a subject from walls or fill cards, and when a more specular source is needed for a specific effect.

Umbrellas range in size from small (24 inches) to massive (72 inches). My favorite is a 60-inch satin white umbrella. I suggest owning as many different ones as you can get; with different sizes, you can achieve similar effects from different distances. I also recommend purchasing them in matched pairs. There will be times

IMAGE 4-9. I liked the shadows that were playing inside this old building in Santa Barbara, which was lit from behind from a cloudy, hazy sky. For this shot, I placed one speedlight in a shoot-through umbrella at full power to increase the overall ambient light on Briana from the front. It was placed to camera left, just out of view. A second speedlight with a bare head was placed to camera right and aimed at her. I set that light $^{1}/_{2}$ stop over the ambient and shot at that exposure. The sunlight still added backlighting on her hair and the cactus, and the building was very well lit. The little shoot-through umbrella added just enough to fill in the black dress and the overall foreground.

when you'll need two light sources and matching units will provide greater consistency—and if they are used in front of the subject, the catchlights from a matched pair will be not be as distracting as those from two different sources.

IMAGES 4-10 AND 4-11 (ABOVE AND RIGHT). Briana was photographed with a single 60-inch umbrella. No fill was added on either side of her. I wanted the light from the umbrella to wrap around her, but also to have modeling on the back of her shoulders and on her cheeks. Not providing any fill in those areas gave the light a direct, on-axis feel. If you look at the edges of her shoulders, arms, and face, you will see the light start to fall off. You can also see the background "spray" light in these shots. The closer the light gets to the background, the tighter the spray looks.

IMAGES 4-12 AND 4-13 (BELOW, LEFT AND RIGHT). These are the resulting images. You can see how the spray light, the darker edges of the subject, and her dramatic poses combined for a pretty dramatic look.

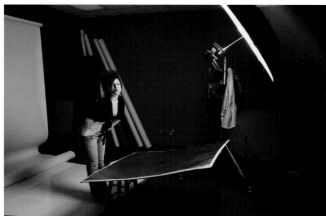

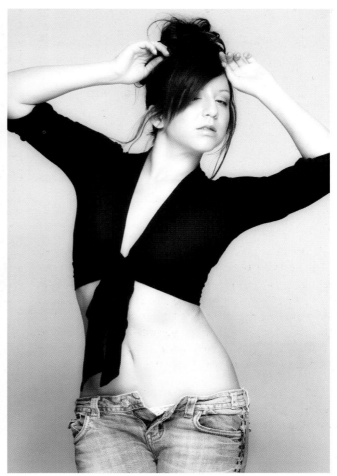

IMAGES 4-14 AND 4-15 (ABOVE). These setup shots show the placement for the large fill card I use under the subject in many shoots. This card has a semi-shiny finish that provides a secondary level of light as it bounces light from the umbrella toward the subject. You can see that the card is tilted. To get the right position, I stand behind the model and look at the card as the model sees it. I want to see that bright highlight in the shiny board that tells me that the light is indeed providing a full reflection.

IMAGE 4-16. The resulting shot of Briana shows how the light falls across her with little downward shadows. Notice that I didn't use side fill; I like the little dark edges on her arms at the camera-left side. The focused light from the front fell away on the sides and provided nice separation from the background.

IMAGE 4-17. This shot shows one of the reasons I love the 60-inch satin white umbrella. Placed far enough away from the subject to get a full shot, the wrap is still observable. Note how soft and faint the shadow is behind her. The 60-inch umbrella "sees" behind her and delivers soft, directional light. Notice how the light also falls off across the cycloramic background. Control of the direction is also something I like to have.

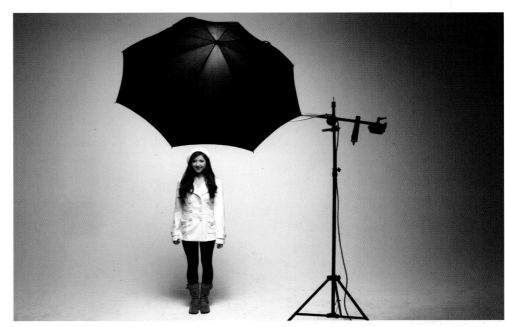

IMAGES 4-18, 4-19, AND 4-20. The top left image is a clarinet photographed in open sun. You can see the terrible effect of the direct light. The specular highlights are sharp, there are very harsh shadows, and the silver keys don't look good at all. The bottom left image is the same shot with the addition of the scrim between the sun and the subject (as seen below). The scrim effectively takes a very small light source (the sun) and makes it very large in relation to the subject. Now we see the clarinet's beautiful silver keys and a "liquid" highlight runs along the black body of the instrument. You will also notice a white card in front of the clarinet. This helped fill in from the front and gave the keys facing it something bright and smooth to reflect.

I like both shoot-through and bounce umbrellas—and I use both. I base my decision on what amount of light I want to wrap and if I want to have the natural bright center in the light that the shoot-through umbrella provides. (Of course, as the light gets farther back, the nuances of this effect become less noticeable.) There are times to use the shoot-through umbrella, and times to shoot with the bounce umbrella.

Large Parabolic Umbrellas. A rather esoteric tool is the large parabolic umbrella. I say "esoteric," because until recently they were very expensive and exotic tools to use.

Parabolic umbrellas have a unique ability to send the light out of the umbrella at the same angle and power from the bottom of the umbrella to the top. This particular ability makes them important to fashion shooters and photographers who want a single-light look without shadows on the floor. The extreme size of the parabolic means that it can provide totally even lighting on a

model from head to toe—and the edges of the light will wrap behind the model to eliminate, or at least greatly reduce, any shadows on the floor.

Parabolics come with white or silver interiors. I have both but find I use the silver more often. Although it is a more specular light source, silver parabolic umbrellas behave quite differently on the subject than smaller silver umbrellas do. I ascribe that to the incredible evenness of the light coming from the parabolics. Parabolics are something a lot of photographers will be looking at adding to their arsenals. Do beware of taking them outside though; a little breeze turns them into low-flying UFOs—and being interrogated by Homeland Security for a couple of days would be no fun.

SCRIMS

Scrims are usually fabric that is stretched in front of the light source to make that light source much larger and, therefore, much softer. Scrims can turn a small speed-

light into a 4x6-foot light quickly and with reasonable efficiency.

My light kits all have a pair of shower curtains (from Target) in them. The solid white cloth ones are what you want, not the plastic ones. Plastic can catch fire with hot lights too close to them (please, trust me on this one). I use these shower-curtain scrims for lots of work. I can drive a speedlight through one and turn a hard, contrasty light into a fantastically soft light. I can use gaffers' tape to attach one to a wall and bounce a light off of it, which is helpful in areas where the walls are blood red or sickly green. Outside, I use my shower-curtain scrims and silk scrims to mitigate the bright sun. The silk ones are a bit more expensive, but they also let in a little more light. Positioned above someone standing in bright sun, the scrim becomes the light source—much larger and softer than the small sun above.

You can, of course, purchase scrims made for photographers from vendors like California SunBounce and they work wonderfully. I like them for their size, but the ability to fold up a shower curtain and throw it in the bottom of my lighting kit is something I really value.

SOFTBOXES

Softboxes range from very small to quite large. My smallest is about 12-inches square; my largest is 4x6 feet. The light source is positioned in the box, which is black on the outside and white on the inside, and directed through the translucent white fabric on the front

IMAGE 4-21 (ABOVE). This was the setup for a cover I shot for a catalog company. You can see the tethered laptop and softbox on a boom. The goal was to create a very simple image that looked like the product in use. We created it in the living room of the client's sister. There was a lot of ambient light flowing in, and I wanted to maintain the warmth of the existing home for the background. The white card you see leaning against the table was placed opposite the softbox on the other side of the glassware.

IMAGE 4-22 (RIGHT). In the resulting image you can see the square highlight and square fill card reflected on the glassware. These carefully placed highlights helped define the shape of the glass.

HOW MANY LIGHTS DO YOU NEED?

How many lights you need will depend on what kind of work you want to do. I have four Profoto Compacts, two Dynalite heads, an old Norman with five heads, and a bunch of speedlights. Add to that the cinema lights and fresnel spots, and I have more lights than I normally use on any one shoot.

I recommend starting with three lights. At least two of them should be matched for power. The third can either be a very powerful instrument or one of lesser power than the other two. This should be able to deliver a nice spectrum of light for portraiture, product, still-life images, and simple commercial work.

I also do a lot of work with a single light source. I love the look of one light, and many times I will simply work with a light and an umbrella or softbox. The ambient light is frequently a part of my work, as well—and what I choose to do with that light can make the difference between whether I use a single light or multiple units.

of the box. (*Note:* Some softboxes have an additional baffle inside to diffuse the light before it gets to the front surface, assuring that any hot spot from the source won't affect subjects lit by it.)

I use softboxes all the time in my work. Softboxes work much differently than umbrellas; where the light from an umbrella tumbles out from a bounce umbrella or spreads out from a shoot-through umbrella, the light from a softbox is gentle and constrained by the confines of the unit itself. Softbox light is directional and soft.

Softboxes work well for lighting people. For portraits, I use my large softbox as I would window light, allowing it to create a very large, soft effect on the subject. The clean, squared-off catchlights it creates help maintain the illusion of a large window. Softboxes are also optimal light sources for still-life and product photography. The shape of the softbox is of particular benefit when lighting items that are shiny and will necessar-

ily reflect the source of the light. An umbrella's round shape (as well as the ribs that provide structure inside it) does not work well for lighting such items, but the smooth, well-defined edges of a softbox can be used to great advantage.

Strip Lights. A strip light is simply a very tall and narrow softbox. Strip lights are used to create large-light looks when actually *using* a large light source would spill light into places where the photographer doesn't want it. The narrow shape of a strip light helps control spill while still providing a large, smooth light source for a specific area.

CHOOSING THE RIGHT LIGHTING

When I talk about consciously choosing the type of lighting that you are going to use for a subject-centric approach, please don't think I am being terribly granular. I am usually not thinking, "I need to place the 43-inch umbrella at four feet with a fill card at 23.5 inches and then add an umbrella hair light with the zebra interior and a speedlight on a boom at 14 inches . . ." Rather, I am thinking in generalities like, "I want a large, soft source from the left and an edge light to separate a bit. Maybe an accent light on the face—yeah, that would look cool."

I then begin to plan the setup using the tools I have and within the space where I'll be working. My current studio is big enough to shoot a truck with a boat on a trailer, but I have also shot in some extremely tight quarters. This part of photography is pure problem solving—and it comes into play quite often.

Without understanding how different subjects look under the multitude of different light sources at our disposal, though, how could we begin to address the challenges of inadequate space and less-than-perfect working areas? We couldn't. We would simply have to set up some umbrellas or softboxes and waste precious time trying to make them do something that another tool might do more efficiently—if we had thought from the subject out instead of the light in.

IMAGE 4-23. In this shot you can see a 22-inch beauty dish used about 32 inches from Briana. I placed a fill card below the light to add some light under her chin, creating lighter tones to offset the predominantly dark tones of her dress and the background.

IMAGE 4-24. This image shows the vertical and on-axis position of the beauty dish to provide very direct lighting. I like the way the beauty dish presents the face and lets the sides drop off quickly. This models the face for a striking look.

IMAGE 4-25. Here you can see how fast the light fell off on the camera-left side of her cheek—and yet the hair on both sides of her face was still lit with beautiful specular highlights. That is the power of the beauty dish in close; it's bright, poppy, and very flattering.

IMAGE 4-26. Working her face toward the beauty dish provided wonderfully soft lighting with dramatic fall-off to the sides. This is accentuated by not adding any fill light on her cheeks.

BEAUTY DISHES

The basic shape of a beauty dish is a wide, flat pan with a flash tube coming in from the back. The depth of the "dish" equals the height of the flash tube so the light spreads out from the flash head and is then caught by the sharply rising edges. A blocker in front of the flash tube reduces that intensity from the center—and the light from the sides will, in most cases, hide that small piece of metal as it blasts back across the front of the dish. (*Note:* There is a newer shape to beauty dishes out there as well: the Mola. The Mola has two distinct "pan" areas with gentle slopes in between. It retains the blocker in front and the sharp lip on the side and provides a very similar light to the flatter beauty dishes.)

Most beauty dishes have a very sharp "lip" area that helps keep the light focused and creates a very fast fall-off from the central area—and the center area is where the fun happens. The beauty dish provides flat, even lighting across a very small area. I find that the beauty dish works best when it is placed at a distance from the subject that is no more than three times the diameter of the dish. In other words, a 20-inch beauty dish works to best advantage when placed within the 60 inches of the subject. If you move it farther back, the light functions like an umbrella, but with a sharper edge. (That is not to say that beauty dishes should not be used at greater distances, only that the true effect of the beauty dish is mostly seen when it's placed closer to the subject.)

Beauty dishes are usually made of steel or aluminum and do not bend in the wind. That makes them a good choice for shooting on location when there is a breeze (or other obstacle) that would make using umbrellas inconvenient. While a slight breeze can invert and destroy an umbrella, a beauty dish can take a pretty stiff wind without any harm. Of course it has to be held down somehow—it still takes to the wind and wants to fly.

GRID SPOTS

Grid spots look like honeycombs with differing cell sizes. When placed over a reflector, the grid lets the most light escape straight through the middle; it begins to

IMAGE 4-30. The dramatic fall-off from a grid spot aimed at the studio wall. Notice how the grid keeps the light centered and then falls off quickly, but with a softness to the edge.

IMAGES 4-27, 4-28, AND 4-29. A single grid spot can be quite dramatic—but it can also be a challenge if the subject is not perfectly placed. In the first shot of Lynne (below left), I kept her chin up; I didn't want to increase the shadow under her neck from the grid spot, only to use the dark shadow to define her face. I added a 42-inch umbrella to camera left, slightly behind her, to give her arms and hair some definition. That light was too far behind her to make it to her face; only the grid spot was on her face. For the bottom right image, I turned Lynne's shoulders toward the umbrella, allowing her skin to catch some light from that large source. You can see how nicely it defines her chest and arms. The grid still provided the only illumination on the front of her face.

IMAGES 4-31 AND 4-32 (ABOVE AND RIGHT). I moved the umbrella to the front of Lynne, keeping it at 2 stops less than the main. Since it is at a different angle from the camera, it doesn't provide the same specular look as we saw in the previous setup. While the contrast is very evident, there is also more light on her dress, arm, and shoulders. The main light on the face, however, is still the grid spot at f/16.

IMAGES 4-33 AND 4-34 (BELOW, LEFT AND RIGHT). Here, I moved the umbrella in closer, increasing its effective output by 1 stop (making it now only 1 stop less than the grid spot). The resulting image shows a very pleasant feel to the fill. The main light still has a grid spot feeling, but the shadows are significantly mitigated.

constrict the light as it goes out from the center. Consequently, a grid spot has a very bright center from which the light falls off smoothly and rapidly. How big that center is and how fast the light falls off has to do with how small the cells are and how deep the grid is.

I use grids a lot in my work, sometimes for faces and sometimes for backgrounds. The grids give me small amounts of focused light without hard edges, but they also allow me to feather the light (see chapter 7) for soft blending effects with the other lights—or for adding drama with shadows.

Grid spots are available for nearly any kind of light you have, from speedlights to large studio lights. I recommend at least one grid spot for any lighting kit.

SNOOTS

Snoots are long, tube-shaped, and very restrictive lighting modifiers that create a spotlight effect. Like grid spots, snoots force the light into a more concentrated central beam; unlike grid spots, snoots produce light with a very fast fall off at the edges. The light-to-dark transition is immediate and easily noticed. Snoots can be used with great advantage to add light to a small part of a subject, and where a "spotlight" effect is desired.

COOKIES

Cookies are devices that are placed in front of the light to create shaped shadows. They are used to add drama to a background or intrigue to a subject. There are store-bought cookies and there are homemade ones—I prefer the homemade ones, myself. To make them, I cut shapes into black cards, then attach the cards to stands in front of the light sources. The light passes through the cookie and creates patterns on the subject it is lighting. (*Note:* Cookies do not work well with soft light; hard light is needed to define the shapes.)

FLAGS

Like cookies, flags are also put in front of the light—but not to make a shape. Instead, flags are used to block the light from reaching places the photographer doesn't

IMAGES 4-35 AND 4-36. These photographs of Briana were shot with several hot lights. I used cookies to block parts of the light so they wouldn't create just a wash across her torso and face. I placed them carefully to give a soft edge to the deep shadow of the cookie. The closer the cookie is to the light, the softer the shadow becomes; moving it farther away gives the shadows more of a sharp edge. I wanted the patterns to be seen, but not to be harsh.

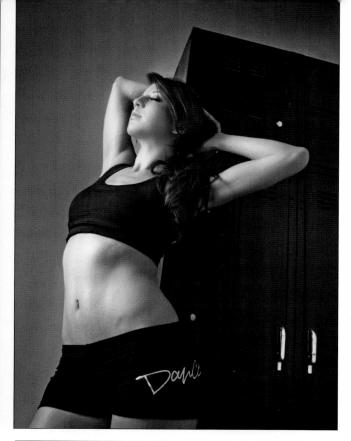

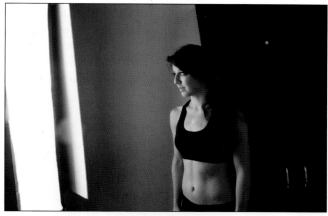

IMAGES 4-37 AND 4-38. This shot was made using a very broad light source, very close to the subject. Briana was bathed in soft light, filled from large cards to camera right. You can see the reflections of the cards in the lockers—that creamy, liquid highlight that sweeps across the black lockers. Notice the two flags in the setup shot. One was to the back edge of the light, angled in toward it to keep the light off of the background. The second flag kept the light from overextending along the fill cards. To get some gradient on the lockers, I angled them to the light.

IMAGES 4-39 AND 4-40. This is my favorite image from the shoot. By changing the angle, I added some drama. From this angle, Briana looks powerful and athletic—which she is, by the way. You can see how the choice of the soft light makes the shot more accessible and real. In the setup shot, notice how the light is brighter on the fill cards as it is closer to the lockers. That means the reflection will be reversed, of course, with the lightest area reflecting from the back of the shot and the darkest area around where Briana will be standing against it. It was just more interesting to me that way.

want it to fall. Flags can be used to keep light off of backgrounds and subjects, as well as to prevent it from striking the camera and causing flare. I keep a nice stash

of cards and black foam-core board that can be cut and clamped to stands for use as flags. I find them to be absolutely imperative for location shooting.

SUPPORTING THE LIGHTS AND MODIFIERS

I am often asked how many stands a photographer should own. My answer? One more than you have on any given shoot. Seriously.

I use several different kinds of stands for different kinds of work. I need stands that can reach pretty high, and I like stands that are stable. Putting an expensive lighting instrument on top of a rickety stand scares me. I like stands that hold their lights without swaying or tipping over at the slightest bump. For most of the height work I use Bogen, Manfrotto, and Savage stands. They will go from 12 to 20 feet. These stands are not chosen for their portability or light weight; I just want them to stand tall in a breeze or hold a large light at a very tall height.

C-Stands. C-stands (or Century stands) are an offshoot of the stands they use in Hollywood and on video productions the world over. They are used to hold very heavy instruments in very difficult situations; their unique foot design make them nearly impossible to knock over.

Booms. One of the most important tools you can have in your arsenal is a boom. The ability to place a light *without* a visible stand is invaluable. A boom puts your light where you want it—without the corresponding vertical element that has to be retouched out in every frame. I use booms for backlights and on-axis lights, as well as to add light to a corner of a set. I have many and I use them on nearly every shoot I do. I would be lost without a good boom or two.

Booms have counterweights to offset the weight of the light instrument. These are terribly hard when you bump your head on them, so I keep mine painted a bright color and even have soft towels that wrap around them to reduce the impact of the occasional forehead bump. (Hey, I'm a photographer. I didn't claim to be graceful.)

IMAGE 4-41. I purposely underexposed this image by one stop to get the deep blue sky. Megan was lit by a small softbox being held about two feet from her by Frank Tuttle. (Yes, I know you cannot see Frank in this picture. Photoshop is a wonderful tool.)

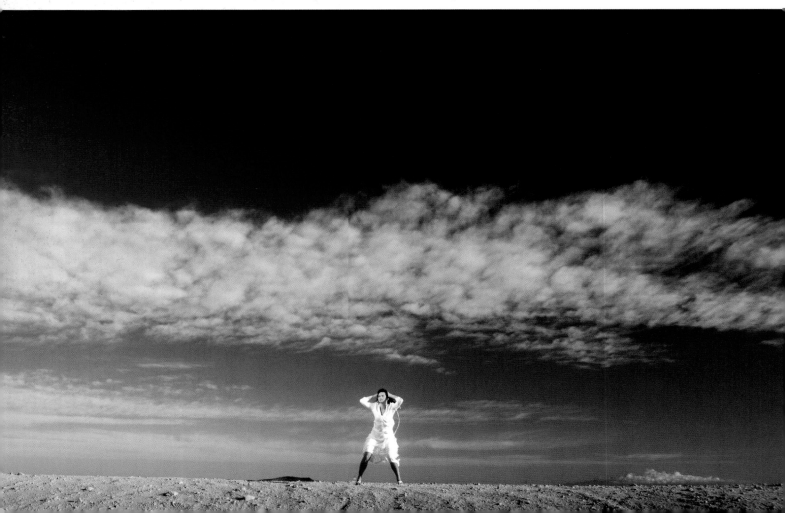

5. EXPOSURE ESSENTIALS

Exposure is the controlled capture of light on the sensor (or film) in relationship to specific tonal values in the subject or scene. According to traditional guidelines, in a "well exposed" image a white wall will be white, while a dark gray sofa will be dark gray. Essentially, a photograph is considered to be perfectly exposed when the tonal luminosity of the real-life subject is accurately expressed in the captured image. However, in many ways what constitutes a "correct" exposure is up to the photographer. In this chapter, we'll begin by looking at how we can control exposure, then move on to considering the more creative aspects of this important topic.

EXPOSURE CONTROLS

Exposure is controlled by adjusting the light sensitivity of the camera's sensor (the ISO setting), managing the amount of light allowed to strike the sensor (the aperture setting), and setting the duration of time over which light is allowed to strike the sensor (the shutter speed setting).

Accordingly, these are the three values we use to describe exposure; we might say that an exposure was f/4 at $\frac{1}{250}$ second and ISO 100. These numbers have mean-

IMAGE 5-1 (TOP). It was getting a bit late in the afternoon in Santa Barbara when this shot was made. The sun was nearing the fog bank out on the horizon and becoming a little weaker. I wanted to use the lifeguard station as a compositional element and feature Briana against the sky. I used two bare speedlights on tall stands to reach up to her height. These were set to matching exposures. The light was to wrap around her—the sun on the left, a middle speedlight, and an edge speedlight. That's what was needed to achieve the effect I was looking for: a fully lit swimsuit shot on a sidelit scene. (By the way, the anonymous guy on the right was just perfect for me.)

IMAGE 5-2 (BOTTOM). Here is the setup shot for Briana on the lifeguard station. You can see the two lights and the placement used.

ings that make sense when we understand the mechanics of exposure. For example, f/4 is a wide aperture, a large lens opening, which allows a great deal of light to reach the sensor. A shutter speed of $\frac{1}{250}$ second means the light was only allowed to hit the sensor for a very short time. The sensor had a sensitivity of 100 (quite low on the ISO scale). Knowing that the light was only allowed in for such a small amount of time and that the sensor was at its weakest sensitivity while the aperture was wide open can tell us a bit about the light present. It was fairly weak, possibly open shade with some ambient light coming into the scene, or possibly a heavy overcast day. It was not midday in the sun, as the aperture is too wide open. It is not late evening light because the shutter speed is too high. (Or, of course, the image could have been shot with flash—but we aren't talking about flash at this point.)

Let's get our minds around an important concept here: any 1-stop change either doubles or halves the amount of light being recorded in the image. For example, ISO 100 is *half* as sensitive as ISO 200, while ISO 400 is *twice* as sensitive as ISO 200. Shutter speeds work the same way; if the exposure setting changed from $\frac{1}{100}$ to $\frac{1}{200}$ second, it would make the image one stop darker (half as much light). Conversely, if the exposure setting changed from $\frac{1}{200}$ to $\frac{1}{100}$ second, the image would be one stop brighter (twice as much light).

Apertures work identically but have a nomenclature all their own; you must simply memorize the apertures so you can quickly calculate changes in your head. The most common ones you will be working with are (in order) f/2, f/2.8, f/4, f/5.6, f/8, f/11, f/16, f/22, f/32, f/45. A setting of f/2 is a very wide aperture and allows a lot of light into the lens. An f/32 setting is very small and doesn't allow much light in. Each of these numbers represent full stops in exposure. Changing from f/8 to f/11 is a 1-stop change (halving the amount of light hitting the sensor). Changing from f/4 to f/11 is a 3-stop reduction in the light reaching the sensor.

APERTURE SETTINGS ON DSLRS

Our digital cameras have now been calibrated with $\frac{1}{3}$-stop increments. I suggest that you learn them as well as the full stops.

f/2, f/2.2, f/2.5, f/2.8, f/3.2, f/3.5, f/4, f/4.5, f/5, f/5.6, f/6.3, f/7.1, f/8, f/9, f/10, f/11, f/12, f/14, f/16, f/18, f/20, f/22

Most modern meters are also calibrated with these numbers, so it makes sense to use them in our discussions. We will be using $\frac{1}{3}$-stop increments in this book.

EXPOSURE TOOLS

In most cases, your exposure decisions will begin from a single setting (why you might choose to start your decision-making from one setting rather than another will be addressed later in the chapter). When you have determined a desired value for one setting, you can adjust the other two exposure controls to determine how much light will be recorded in your capture. The chart below shows you how this works—and we'll break it down into more detail as we move ahead.

IF WE DECIDE ON:	WE CAN CHANGE:
Shutter speed	Aperture and ISO
Aperture	Shutter speed and ISO
ISO	Shutter speed and aperture
Shutter speed and aperture	ISO
Aperture and ISO	Shutter speed
Shutter speed and ISO	Aperture

A Constant Aperture. For the exposure settings in the chart below, the aperture remained constant, but the shutter speed was set progressively faster. To com-

A CONSTANT APERTURE						
ISO	100	200	400	800	1600	3200
SHUTTER SPEED	$\frac{1}{50}$	$\frac{1}{100}$	$\frac{1}{200}$	$\frac{1}{400}$	$\frac{1}{800}$	$\frac{1}{1600}$
APERTURE	f/8	f/8	f/8	f/8	f/8	f/8

IMAGE 5-3. F/8 at ISO 100 and ¹/₁₀₀ second.

IMAGE 5-4. F/8 at ISO 200 and ¹/₂₀₀ second.

IMAGE 5-5. F/8 at ISO 400 and ¹/₄₀₀ second.

IMAGE 5-6. F/8 at ISO 800 and ¹/₈₀₀ second.

IMAGE 5-7. F/8 at ISO 1000 and ¹/₁₆₀₀ second.

IMAGE 5-8. Shot at ISO 100, this image looks smooth without any discernible grain.

IMAGE 5-9. Shot at ISO 1600, this image shows a lot of grain and contrast.

pensate, the ISO setting was adjusted up incrementally (so less light was to make the image).

In **images 5-3 through 5-7**, you can see this in practice. Notice that the exposures match—but there *are* some trade-offs. The two close-up shots (**images 5-8 and 5-9**) show the difference in graininess and contrast in the two images.

A Constant ISO. For the next example (see the chart to the right), I decided on the ISO I wanted, then made the shutter speed faster. You can see that I had to open up the aperture to compensate for the shorter time the shutter was open. Making the hole larger let in

more light, which compensated for the light reduction caused by shorter shutter speeds.

A CONSTANT ISO SETTING						
ISO	200	200	200	200	200	200
SHUTTER SPEED	¹/₅₀	¹/₁₀₀	¹/₂₀₀	¹/₄₀₀	¹/₈₀₀	¹/₁₆₀₀
APERTURE	f/16	f/11	f/8	f/5.6	f/4	f/2.8

The Sunny 16 Rule. A good way to practice calculating these exposure settings is with the Sunny 16 Rule. To get started, take out your camera on a bright, sunny day. Set the ISO to 100, the aperture to f/16, and the shutter speed at ¹/₁₀₀ second. Then, take a photograph of

IMAGE 5-10. This old carousel in San Diego caught my attention and I wanted to design a shot that made it look a bit different. Exposure settings of f/6.3 at ¹/₈₀ second and ISO 100 were chosen for a couple of reasons. The aperture was enough to underexpose the ambient light by 1 stop at the chosen shutter speed. The shutter speed was good, too, because it was fast enough to stop the movement of the carousel, while also being within the range of my flash sync. Using a Canon 20-35mm L lens, I handheld a LumoPro 120 strobe at ¹/₂ power over my head and tried to catch the carousel at the exact moment when I could see the medallion area straight on. I shot about ten frames to get the one I wanted.

something in full sun. It should be correctly exposed— if it is indeed a bright, sunny day.

This is the core of the Sunny 16 Rule, a guideline that has been around for a long, long time. Here's what it says: On a bright sunny day with no clouds over the sun, you can get a correct exposure by setting the camera's aperture at f/16 and adjusting your shutter speed to the inverse of the ISO number (putting a "1" over the ISO number). For example, at ISO 100, you'd use

a shutter speed of ¹/₁₀₀ second. At ISO 200 you'd use a shutter speed of ¹/₂₀₀ second. At ISO 800 you'd use a shutter speed of ¹/₈₀₀ second. (*Note:* For side light-

IMAGE 5-11 (FACING PAGE). Exposure is subjective. Here, I intentionally underexposed the sky and trees and then lit the cactus with a speedlight in very close. The exposure of f/16 at ¹/₂₀₀ second at ISO 100 was 1 stop under the ambient light. The speedlight was brought in to a distance that produced a reading of f/16 on the cactus, then I played around with the angle of the strobe.

SKETCHES AND "SWIPE FILES"

I don't have any problem cutting out images from magazines to keep as my personal stash of great imagery. I sometimes use this stash to inspire new ideas, to convey the style I have in mind to a makeup artist, or to show a type of pose to a model. When trying for a specific "look" on set, a good swipe file can be instrumental in getting everyone on the same page. While I don't use sketches or my swipe file as much these days, I sure used them a lot when I was getting going. It isn't stealing and it isn't copying—unless you *are* actually copying. And even then (assuming you have any style at all), you will almost certainly come out with something different than the sample image.

ing open one stop to f/11. For backlighting, open two stops to f/8.)

As you saw in the previous section, however, you do not have to leave your aperture at f/16—you just need to compensate for any aperture change by adjusting the ISO or shutter speed in the opposite direction. At ISO 200, if you wanted to move from f/16 (with a shutter speed of $\frac{1}{200}$ second) to f/22, changing the shutter speed to $\frac{1}{100}$ second would compensate for the smaller aperture setting. Two images taken at these two settings should absolutely match in color and contrast; there will, however, be a slight increase in the depth of field as a result of changing the aperture.

Let's consider another example. You start out shooting at f/16, ISO 100, and $\frac{1}{100}$ second. Then you decide to change your aperture to f/8. The f/8 setting allows in 2 stops more light than the original setting of f/16; to maintain the same exposure, you'll need to reduce the light by 2 stops using the ISO and/or shutter speed settings. Reducing the ISO by 2 stops would mean setting it at ISO 25 (ISO 100 to ISO 50 to ISO 25 is a 2-stop reduction)—but that isn't feasible on most digital cameras. Instead, you will have to choose a shorter shutter speed. To make the shutter speed faster by two stops, you'd choose a setting of $\frac{1}{400}$ second ($\frac{1}{100}$ second

to $\frac{1}{200}$ second to $\frac{1}{400}$ second is a 2-stop reduction). A photograph you take at this setting will match the first image, except it may reveal a reduced depth of field (depending on what you were photographing) due to the aperture change.

SAMPLE SHOOT: A Pink Wall. Using the Sunny 16 Rule, I shot this pink wall near my studio (**images 5-12 through 5-17**). You can see that all of the captures match, despite being shot at different camera settings. It is vital that you understand the relationship between ISO, shutter speed, and aperture.

MAKING CREATIVE DECISIONS ABOUT EXPOSURE

So, you now know that you can approach exposure using through three different controls: ISO, shutter speed, and aperture. You also know how those controls work together and can be manipulated harmoniously to produce the exposure you want. But how do you decide which combination of equivalent exposure settings is right for the image you want to create? As a photographer, you need to decide quickly what will work best.

Shutter speed may be your priority if your image involves motion. Do you need a fast shutter speed to freeze the action? Or maybe a slow one to blur it?

Aperture has to do with the depth of field (the depth of sharp focus) in the image. Will more depth of field be required to make sure all the elements of the composition are in focus? Would a more shallow depth of field be better—maybe to blur the background? (See the end of this chapter for more on aperture selection.)

The ISO affects how much grain you may see in your image. Most modern cameras (2009 and later) have had significant noise decreases, even at higher ISO settings—but as we saw earlier in this chapter, there are still differences between high and low settings that need to be considered.

Previsualizing the image, understanding how you want your subject to look, will answer a lot of these questions. Does the image in your mind a shallow depth of field with a blurry background and just the subject in focus? If so, your first decision will likely be about the

IMAGE 5-12. F/16 at ISO 100 and $1/100$ second.

IMAGE 5-13. F/11 at ISO 100 and $1/200$ second.

IMAGE 5-14. F/8 at ISO 100 and $1/400$ second.

IMAGE 5-15. F/5.6 at ISO 100 and $1/800$ second.

IMAGE 5-16. F/4 at ISO 100 and $1/1600$ second.

IMAGE 5-17. F/2.8 at ISO 100 and $1/3200$ second.

aperture; the other settings will follow that. Or maybe the image you're imagining features something frozen in motion? In that case, you'll want to start of by selecting a shutter speed that's fast enough to freeze the subject's movement.

SAMPLE SHOOT: On the Beach. Image 5-18 was taken on the beach at Anna Maria, FL. The sun had been down for a few minutes, so we were dealing with the remnants of the light. I love this time of day, though, so I wanted to do one more shot.

The lens was a 20–35 Canon L and I used a shutter speed of $\frac{1}{20}$ second—the slowest at which I would ever want to handhold while kneeling in the sand. At ISO 100, an ambient-light exposure at f/4 captured beautiful color in the sky along with a very subtle reflection on the water. At a smaller aperture, I would have had to raise the ISO or choose a longer shutter speed, eliminating my ability to handhold the camera.

To light Briana, I added two speedlights, one over my left shoulder and one behind the model to camera right. Both were placed at a distance/power to give f/4. (*Note:* The rim light seems a bit brighter because it just glances off the edges of her skin, reflecting the light back into the camera.)

THE EXPOSURE "SWEET SPOT"

I have a theory about the "sweet spot." It has to do with the shutter speed part of the exposure calculation. For most subjects, shutter speeds outside the range of $\frac{1}{30}$ second at the low end to $\frac{1}{250}$ second at the high end reflect the law of diminishing returns. We probably all agree that if something is blurry at $\frac{1}{30}$ second, it will not be any sharper at $\frac{1}{15}$ or $\frac{1}{8}$ second—or any slower shutter speed. Likewise, if something can be frozen at

IMAGE 5-18. Shooting at ISO 100 as the light was fading, a wide aperture setting was needed to maintain a shutter speed at which I could handhold the camera. It also provided a pleasingly shallow depth of field.

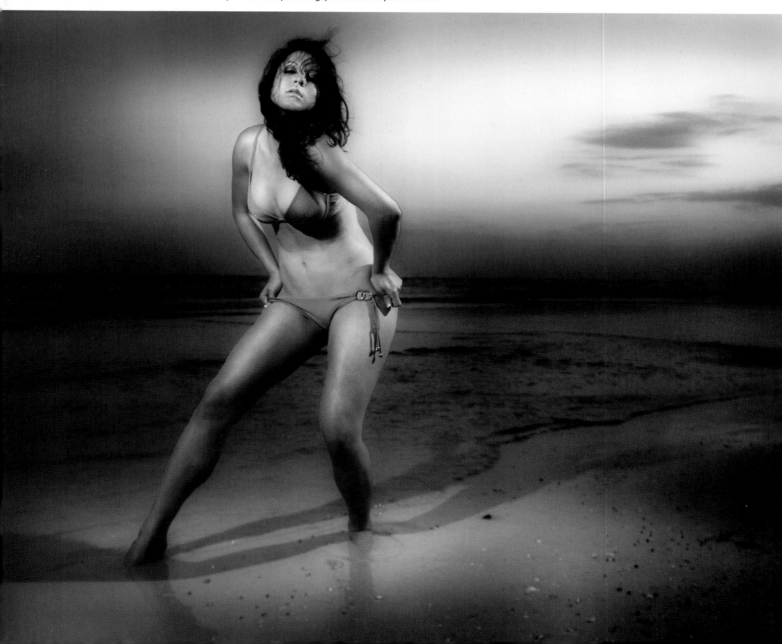

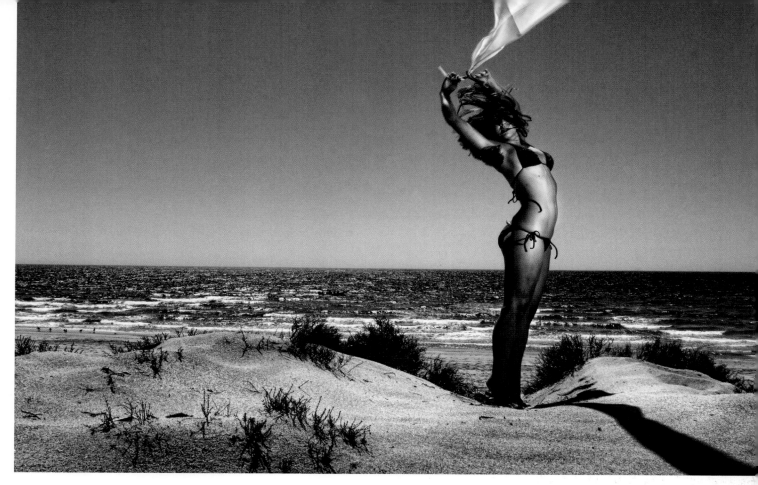

IMAGE 5-19 (ABOVE). It was hot in Mexico, and we were killing some time in the heat of the day. Briana was on the sand dunes with the Gulf behind her. I used a speedlight against the sun and made some shots of the little scarf blowing in the wind. Shadows abound, making the shot fun and showing the contours of both the sand and the model.

IMAGE 5-20 (RIGHT). This photograph, taken for the Chase Jarvis Shoe Project, was part of a fun project on Flickr. Chase donated a pair of his shoes and they were sent from photographer to photographer. Instead of putting them on a model or placing them in a street, I chose to actually shoot the shoes. The very close focus on the Canon 50mm f/1.4 with a close-up tube allowed me to isolate small details and surround the sharply focused area with soft, out-of-focus light and texture.

$\frac{1}{250}$ second, it won't be any more frozen at $\frac{1}{500}$ or $\frac{1}{1000}$ second. Within that sweet spot from $\frac{1}{30}$ to $\frac{1}{250}$ second, however, a lot can happen to change our image. Something that is frozen at $\frac{1}{250}$ second may not be sharp at $\frac{1}{125}$ second. And something sharp at $\frac{1}{60}$ second can fall to pieces at $\frac{1}{30}$ second.

With film, if we didn't want to accept a blurred shot, we had to make some choices. And remember: with roll film, photographers couldn't change the ISO mid-roll as the whole roll had to be developed at one time. The differences between ISO 100 Ektachrome and ISO 200 Ektachrome were huge. If we "pushed" the film (devel-

oping a lower ISO film as a higher ISO film in order to gain sensitivity) it increased the grain and decreased the saturation to a huge degree.

So we bought lenses with f/2.8 apertures in order to gain that extra stop of shutter speed. It could mean all the difference in the world to be able to shoot f/2.8 at 1/125 second with ISO 100 rather than have to choose (at f/4) between a blurry image at 1/60 second or a grainy image with ISO 200 film.

These days we have ISO settings of 800 that are virtually as clean as ISO 100 film, so that obstacle has been overcome—but the reality of the sweet spot still exists. For example, I practice the guideline of not handholding my camera at shutter speeds longer than the inverse of the focal length of my lens (this means putting a 1 over the focal-length number). For example, handheld shooting with 200mm lens necessitates a shutter speed that is 1/200 second or faster. This keeps my images sharp and lets my tripod get a full workout.

An additional advance has been the introduction of image stabilization (IS) or vibration reduction (VR) lenses for most major brands of cameras. These lenses help the photographer handhold at lower shutter speeds by mitigating camera vibration and shake. Some camera manufacturers are even building the image stabilization feature into their camera bodies, making it available across all lenses for that camera.

WHAT IS A "PERFECT" EXPOSURE?

What constitutes a "perfect" exposure has both very technical definitions and more personal definitions. Technically, a perfect exposure has been captured when the image contains the luminance of the objects in the scene with a tonal accuracy that places the middle gray exposure at 18 percent and still has whites with texture and shadows with texture.

Personally, I think a perfect exposure is whatever I say it is. It is a subjective, emotionally driven decision based on what I want the subject to look like in the environment they are in. To me, the image can be blown out in some areas and a little dark in others and still be perfect. The exposure is based on what I want to show and communicate, not a technical calculation made in a laboratory.

Please understand that I am not castigating the science, nor do I want you to think I don't care about

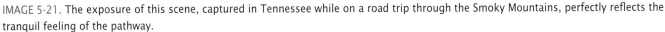

IMAGE 5-21. The exposure of this scene, captured in Tennessee while on a road trip through the Smoky Mountains, perfectly reflects the tranquil feeling of the pathway.

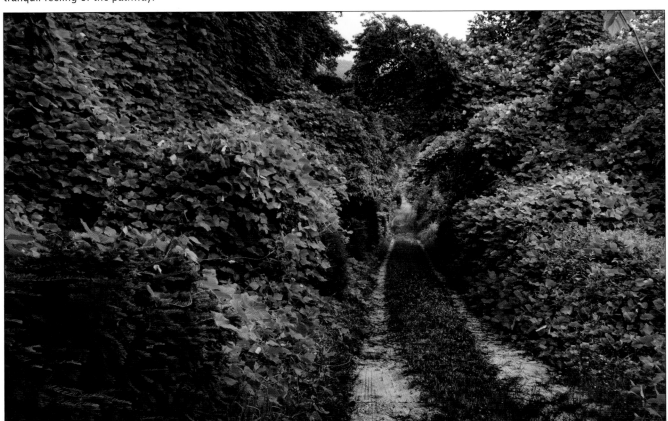

IMAGE 5-22. Slight overexposure on Megan, coming from a different direction than the sun, gives the portrait a sense of mystery.

getting the right exposure. It is exactly the opposite. The science is what puts these exposure controls at my command. However, when it come to rendering each subject as I envision them, I spend more time thinking about the emotional charge of the portrait than the technical definition of what someone considers a "perfect" exposure.

SAMPLE SHOOT: A Captured Moment. Image 5-21 was taken on a very overcast day, about ten seconds before the rain started pelting me. The incredible soft light of the sky opened the shadows so beautifully and also provided a lovely, bright highlight on the leaves. The clay earth was revealed with texture and the shot has a feeling of overall softness. It captures the feeling of the moment.

SAMPLE SHOOT: In the Desert. This shot of Megan (**image 5-22**) was taken in the middle of the desert near Puerto Penasco, Mexico. We could see the arch from quite a distance, just sitting there in the middle of nowhere. Once we figured out how to get there (it was worth the dust), my priority was choosing a fast shutter speed to freeze the wind blowing her hair and dress. Shooting at ISO 400, I experimented a bit to find a good aperture and finally settled on f/7.1. I liked the way the horizon went very bright and then gradually became light blue at the top of the image. It gives you a sense of the very bright light coming from behind the arch.

To light Megan, a speedlight in a small, portable beauty dish was placed just out of frame to camera right. The placement was at the point to provide f/8, which was a bit brighter than the f/7.1 exposure I had chosen. The slight overexposure on Megan gives a feeling of bright light on her face—but the fact that the light is clearly not connected to the light coming from behind the arch gives the portrait a sense of mystery.

IMAGE 5-23 (ABOVE). In this shot of Jazmin wearing a polka-dot dress, the sun was coming over her right shoulder, so I added a speedlight to match it from camera right. This illuminated the dress and face and provided some drama as it fell off across her legs. Shooting with a wide-angle lens, I used the broad depth of field at f/11 to bring the stairs into focus from front to back, contrasting the polka dots and linear architecture. The linear convergence was also enhanced by the wide-angle lens.

IMAGE 5-24 (TOP RIGHT). For this shot of Richelle, I used a 60-inch bounce umbrella as the main light. It was placed very close to her to enhance the wraparound lighting on her face. A white fill board was placed in front of her, just out of camera view. This provided soft, flattering light on her face and legs. To add some contrast, I aimed a bare bulb reflector at her back, skimming it along the wall. This brought out the texture of the wall, added a little something to her hair, and made the image a bit more interesting.

IMAGE 5-25 (BOTTOM RIGHT). While there are times to pull out the strobes and the softboxes, there are also times to bring out a piece of white card and go with some beautiful natural light. Rio was standing on the beach waiting for her next shot when I saw this gorgeous light. There was a large, white reflector right in front of her. I exposed between the ambient front light and the stronger backlight to make the shot look natural and alive.

MORE ON APERTURE SELECTION

I am not a photojournalist or a sports shooter, for whom the first consideration may be shutter speed. Because my work is more set up and controlled, my first consideration is usually aperture and what I want to do with the depth of field. This is a very important part of making an image—and the creative decisions you make about the aperture setting will have a direct impact on the lighting and exposure.

A shallow depth of field can be used to set the sharp subject away from the out-of-focus background. In addition to creating separation, this also renders the light differently on the background than on the subject; a hard, sharp light on the subject will be less hard on the background if it is out of focus. It can define and give edges, without the harshness it would have if you shot with more depth of field in the image.

You can also make images where the depth of field is deep and the light is rendered throughout the image with clarity. These images can pull the subject and foreground/background into a more cohesive relationship. Using soft and hard light, you can render the scene with values that draw the viewer in and reveal texture and color.

ADDITIONAL DEPTH-OF-FIELD FACTORS

There are two other factors, in addition to the aperture selection, that will impact the apparent depth of field in an image. These are the distance of the camera to the subject and the focal length of the lens.

The closer the camera is to the subject, the smaller the depth of field will be in the image. When used at a very close distance, even a small aperture of f/11 may not render much depth of field. This is something to keep in mind when previsualizing your images and setting up your shots.

When it comes to focal length, wide-angle lenses expand the foreground-to-background relationship while telephotos tend to compress it. Wide-angle lenses also have inherently deeper depth of field than telephotos when used at the same aperture and subject-to-lens distance. This means that the angle of reflection (the specular highlights and where they appear) can also change with changes in focal length. The subject and how it renders the light will not change, but how the camera sees it will.

IMAGE 5-26. This shot was done with a 20–35mm Canon L at 20mm—a wide-angle lens. You can see how the deep depth of field keeps the entire scene in focus. To fill in the shadows, a small speedlight was placed on a stand just out of the camera's view and aimed at Briana from slightly higher than her face. It had no modifier on it, but I kept her face aimed right at the light to minimize any harsh shadows. I shot at f/8 and ¹/₁₀₀ second, keeping the sun at 1¹/₂ stops over the speedlight's exposure. This gave the image a sense of the sunlight being the main light—a tiny bit of fill light that almost seems natural.

IMAGE 5-27. This shot was done in the exact same position but with a telephoto lens. The Canon 80–200mm L zoom at 180mm was used to flatten the perspective and throw the background out of focus. Shooting wide open at f/2.8 allowed me to use a faster shutter speed of ¹/₄₀₀ second. This was taken just a few minutes after the wide-angle shot, so the sunlight was pretty much the same.

6. EXPOSURE TECHNIQUES

Meters have been the subject of many discussions on a lot of the photography forums—and there are both proponents and detractors. I offer my assistance whenever I can, but lately the noise about *not* needing them seems to be quite loud. I can tell you seriously that if you *really* don't need one, then by all means don't bother. If what you are doing is working for you, that's fine. However, I have found that nine out of ten people who tell me they don't need a light meter don't know what they are missing. They have never experienced the power and control a meter can give, so they think that it is a waste of time. To me, becoming a master of image-making means understanding all the tools that can help me attain perfection. Knowing exactly what the light is doing gives me the power to make the decisions I need to make.

CHIMPING

Aside from the "fix it later in Photoshop" approach, which I won't even dignify with a discussion, chimping (checking the LCD screen for image feedback) seems to be the preferred approach among those who are not big fans of light meters.

Chimping means taking your attention away from your subject to look at a tiny screen. At a wedding, this can mean missing a once-in-a-lifetime shot. It can mean missing the touchdown or that magic look in your daughter's eye. This approach is also a big problem when working in the sun, where LCDs are hard to evaluate. (And running over to the shadows to try to get a good idea of how your image looks is only a band-

IMAGE 6-1. I like shooting head shots at wide apertures, but in the studio it has been a bit of a challenge because my studio lights are pretty powerful. This photograph of Briana was made at f/2.8 at $^1/_{100}$ at ISO 100. I used a speedlight in a home-made beauty dish (placed in pretty close—only about 14 inches out of frame) and a speedlight for the background to make a spray. I love my big strobes, but the ability to use a very small amount of light makes the speedlights attractive. My newer studio strobes are capable of going down pretty low—but not to this level at this distance.

IMAGE 6-2. Rio and histogram.

IMAGE 6-3. Dasean and histogram.

aid solution, since your eyes are still dealing with the very bright light you were in ten seconds ago.)

"What?" some people ask, "You mean you *never* chimp?" Sure I do. When I am setting up, I take test images to make sure the composition is working and that all the flashes are going off. I want to see the makeup on the model and make sure the garments are looking good. I want to see what the shot will look like in two dimensions, as well as check the depth of field, angle, and overall feeling. However, I don't usually check exposure using a test image unless I am using an exposure measuring tool in front of the camera. A gray card or an exposure target are great for checking exposure, but that exposure procedure is defined using the fixed values of the histogram, not my eyes.

THE HISTOGRAM

Let's take a look at histograms. **Images 6-2 through 6-4** show photographs with corresponding histograms. Can you really tell much by these histograms? There is information there for sure . . . the highlights haven't gone over and we aren't buried in the blacks—but that's not

IMAGE 6-4. Lynne and histogram.

what I'm looking for. I want to see what the midtones are doing. Where are those center spikes appearing? If there is a lot of white in the picture and the image is not

SHOOTING TO THE RIGHT

By Steve Burger

I like to think of RAW files as the large-format option for your digital camera. RAW files will enlarge bigger and with better tonal range. If you haven't shot RAW, you haven't seen the highest quality your camera can produce.

Let's assume that a DSLR has a dynamic range of 5 stops. A 12-bit image is capable of recording 4,096 (2^{12}) discrete tonal values. One would think that, therefore, each stop of the 5-stop range would be able to record some 850 (4096 divided by 5) of these steps. But, this is not the case. The way that it works is that the first (brightest) stop's worth of data contains 2048 steps—half of those available. Why? Because CCD and CMOS chips are linear devices. And, of course, each f-stop records *half* the light of the previous one—and, therefore, half the remaining data space available. Here's how it works:

Within the first f-stop (brightest tones): 2048 levels available

Within the second f-stop (bright tones): 1024 levels available

Within the third f-stop (midtones): 512 levels available

Within the fourth f-stop (dark tones): 256 levels available

Within the fifth f-stop (darkest tones): 128 levels available

This realization carries with it a number of important lessons—the most important of them being that if you do not use the right-hand fifth of the histogram for recording some of your image, you are wasting fully half of the available encoding levels of your camera.

To get the most from your RAW files, try biasing your exposure so that the histogram is snugged up close to (but not past) the right edge of the histogram. When you look at the file in your favorite RAW processing software, like Adobe Camera Raw, the image will likely appear too light. That's okay. Just use the available sliders to change the brightness and contrast so that the data is spread out appropriately and the image looks "right."

This will accomplish a number of things. First, it will maximize the signal-to-noise ratio, meaning less noise in your image. Second, it will minimize any posterization and noise that potentially occurs in the darker regions of the image. Also be aware, though, that this effectively lowers the ISO used to capture the image, requiring slower shutter speeds and/or larger apertures. If you are handholding the camera or shooting moving objects, the trade-off may not be worth the reduced noise level.

Steve Burger is a Photoshop educator and consultant for Pro Digital Image (www.prodigitalimage.com) in Phoenix, AZ. He specializes in working with photographers to increase their image quality and speed up their workflow.

coming up to that range, I need to make some decisions on how to get there.

In the shot of Rio on the beach (**image 6-2**), I can see a nice middle-tone exposure. This gives me room to work the highlights and shadow detail to make the image more interesting and with wider tone values.

Dasean's histogram (**image 6-3**) shows very little deep black in it—but that is exactly how I wanted that shot to be. I could pull the blacks down a bit if I needed to, but this histogram tells me that I have all the needed texture in those dark clothes. The highlights are a bit under white, but I wasn't going for a pure white background; I wanted some depth to it, giving the subject something to stand apart from. A pure white background would have been too harsh for me on this shot.

The shot of Lynne (**image 6-4**) also shows a histogram with very little black. I can process down for the blacks and keep the image within the tonal ranges that I want. While there is no real black in this picture, I like the well-positioned skin tones and midtones.

Histograms are somewhat subjective; a histogram that is all the way pulled to the left is not necessarily wrong if you are shooting something very dark against a dark background. Likewise, one that is way over in the high range is not necessarily wrong if the subject is something light against a white background.

I tend shoot to the high end of the exposure range. I would rather have a shot's histogram data fall to the right end of the histogram (the highlights side) than to the left (the shadows side). This approach, called

"shooting to the right," gives me the most options in postproduction, because there is more that can be done to an image at the high end than at the low end. When given the option to overexpose or underexpose, I choose to go a bit high and bring the blacks back in postproduction.

PLACING THE EXPOSURE

A meter is just a light-measuring device. It measures either the reflectance of a subject or the light that is falling on a subject. However, it does not always represent the "best" exposure. As the photographer, you can choose to shoot above or below what that meter suggests in order to render your subject as you've envisioned. In film days, I found that a slight underexposure rendered more color in the landscapes and skies that I shot. Skin tones for me should be a bit higher on the scale than the meters want to put them, so I compensate by opening up about ½ stop for skin. (I can always adjust in postproduction to perfect the exposure, but it is quite often the best exposure to my taste anyway.)

Placing exposure is one of the most powerful tools you have as a photographer. From underexposure, to overexposure, to right-on exposure, to blending the ambient light, to beating the sun, it is up to the photographer to place the values that the camera will capture.

SAMPLE SHOOT: Overexposing the Skin. Image 6-5 of Briana is a case in point. The exposure settings suggested by the meter were ½ stop less (darker) than this. I chose to bump the exposure on her skin up to a brighter tone. I knew the light on the dress and background would be a bit darker in relationship to her face and that is what I wanted.

SAMPLE SHOOT: Overexposing the Skin (A Little More). Rio was in the light of a fill board and the light meter was giving me an exposure of f/3.5 at 1/640 second and ISO 100 (**image 6-6**). I chose to shoot it at f/2.8, overexposing the shot by 2/3 stop. That exposure gave me the skin tone I wanted for Rio. Knowing that the light is normally a bit warm at that time of day means I have to compensate for that color tone with my skin-tone exposure—and I open up nearly every time.

IMAGE 6-5. Overexposing the image slightly captured the skin the way I wanted and created the right relationship between the subject and background.

IMAGE 6-6. Opening up rendered Rio's skin tones just as I had pre-visualized them.

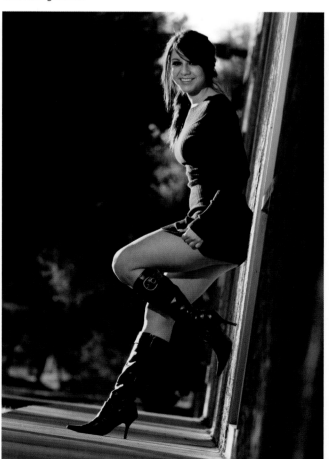

IMAGE 6-7 (FACING PAGE). Underexposing the background allowed me to create the shot I envisioned.

SAMPLE SHOOT: Underexposing the Background. This shot of Earl (**image 6-7**), a fisherman in Cortez, FL, demonstrates just what placing the exposure means. First, I found my ambient exposure by underexposing the background by 1⅓ stops. That underexposure was exactly what I wanted; I "placed" the background to provide a darker presentation. Then, I lit Earl (using flash units) to provide what I considered to be the "correct" exposure on him.

The exposure given by the meter for the background was f/11 at 1/100 second at ISO 100. I used my shutter speed to lower that exposure by 1⅓ stops—that is, I moved the shutter speed to 1/250 second, which is 1⅓ stops less exposure. I placed my lights to give me light on the subject that measured f/11 and set my aperture for that. So the effective f/11 on Earl was correct, but the ambient exposure of the bay and sky was 1⅓ stops underexposed. This is how I placed the exposure to make the shot I saw in my head.

REFLECTED LIGHT METERS

Since the late 1960s, built-in reflected light meters have been a staple of almost every camera—especially the smaller, handheld cameras. These meters measure the luminance of the subject in the lens, calibrate this data with the ISO setting, and return aperture and shutter speed recommendations. This means that the readings they provide are directly related to the subject's ability to reflect light. After all, lighter subjects are lighter because they reflect more light and darker subjects are darker because they reflect less light.

IMAGE 6-8. Here is a shot of an area in my studio lit by a skylight. For this image, I took a reflected light meter reading from the wall with my camera. I then shot at the exposure setting the camera said was right, incorrectly rendering the white wall as a middle gray wall.

IMAGE 6-9. Next, I took a reflected light reading of the flowers and shot at the reading the camera gave me. This incorrectly recorded the flowers at a medium gray level of tonality—and the white wall is now totally blown out.

IMAGE 6-10. Finally, I took an exposure reading from the wall and opened up two stops. That "placed" the wall at a brighter value (but still with texture). The flowers are now correct, as are the shadows. Knowing that the wall is actually white, I knew that I could get it to the correct value by moving the exposure two stops brighter than the middle-gray reading my camera's reflected light meter suggested.

IMAGE 6-11. This image shows the effect of metering off a very dark part of this graffiti-covered wall. The recommended exposure (using center-weighted metering with the camera close to the wall) was f/7.1 and 1/100 second at ISO 100, which rendered the black paint as middle gray.

IMAGE 6-12. This image shows what happened when I moved the camera to get a reflected meter reading off one of the white spots on the wall. The recommended exposure was f/22 and 1/200 second at ISO 100, rendering the white area of the wall as middle gray.

IMAGE 6-13. At the exposure of f/22 and 1/200 second at ISO 100, I knew the white area would be two stops too dark. So I opened up by going to f/16 (adding one stop more light) and then to a shutter speed of 1/200 second (adding the second stop of additional light that was needed). The resulting image is one that has the white placed where it should be and the darks where they should be.

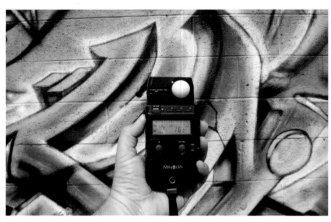

IMAGE 6-14. For this image, using an ambient light meter (rather than a reflected light meter) gave me right exposure setting on the first try—because it measures the light independent of the subject tonality. Read on for more information on this kind of light meter. (*Note:* This old meter does not have the shutter speeds of 1/100 second, so the suggested exposure was 1/125 second at f/16.)

It is important to remember that these meters only tell us how much light is being reflected, not what the "correct" exposure is—in fact, the suggested aperture and shutter stop settings may not even be close to correct. The reflected light meter provides an exposure reading designed to render your subject at a middle gray tonality. That is, it measures whatever you point it at and tells you the exposure setting you would use to render that subject middle gray. If you follow that exposure recommendation, you will get a middle gray subject—but that may not be what you want.

To further complicate things, today's DSLRs usually offer a variety of meter settings with names like "evaluative," "center-weighted," and "spot." And they each do different things. Evaluative metering measures the averages in the scene and makes calculations based on what it sees as a good exposure. (My old Nikon F-3 had a built-in meter that was amazing at the evaluative set-

ting.) I usually choose the spot meter setting. This evaluates a very small part of the scene, generally located at the center point of the viewfinder. Using the spot meter provides the most information about the subject I am shooting, allowing me to evaluate what various parts of the scene are doing so I can make decisions. Based on the values that my meter is giving me and the exposure latitude I have to work with, I can decide how to place each area in my exposure.

As you can see, the meter's ability to measure the light is only part of the image-making equation. You can choose to follow the meter's recommendation or you can override the suggested exposure to capture what you know to be true in the shot.

PRACTICE ASSIGNMENT: The Bride and Groom. At a wedding, you see the bride in her long, white gown standing in the shade of a porch. There is a lot of ambient light bouncing around and she looks marvelous. As you race over to get a shot, you point your spot meter at her dress, carefully line up the meter in your camera to dead center (a "perfect" exposure of $\frac{1}{250}$ second at f/8 and ISO 100), and take the shot.

Next, the groom walks onto the porch you swing the camera over to him. Again, you meter carefully off

IMAGE 6-15 (RIGHT). My daughter Shanna wanted a shot with our dog, so we used a great cactus background in the neighbor's yard. With my in-camera meter, I zeroed in on her skirt (white with dark brown pinstripes) to get an exposure "reading"—a reading, not an exact setting. This is an image taken at that reading.

IMAGE 6-16 (BELOW). This is what happens when I simply open up 2 stops from what my meter told me. Knowing that the white dress should be 2 stops brighter than middle gray allowed me to place the exposure correctly.

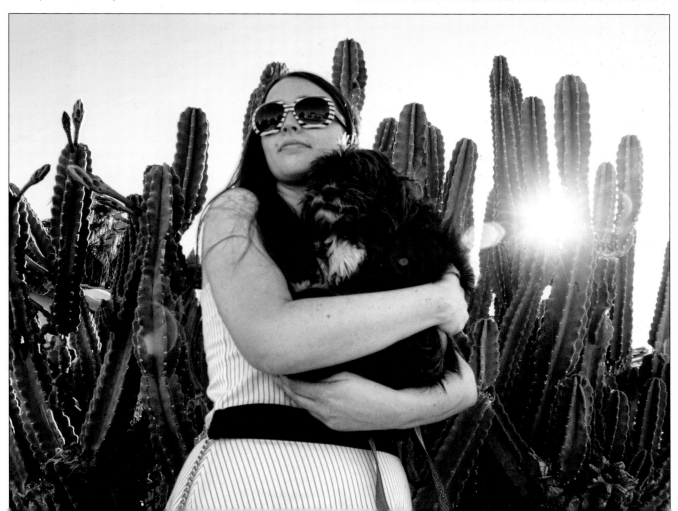

IMAGE 6-17. This is a black shirt rendered as middle gray—exactly to the settings suggested by the center-weighted meter.

IMAGE 6-18. This exposure of Stephanie is not so good. It surely doesn't look like I wanted it to. Clearly, the black shirt exposure is wrong as a setting for the image—but it gave me a good measurement for placing my exposure correctly.

IMAGE 6-19. Knowing that the meter was telling me how to capture the black shirt as middle gray, I changed the exposure to 2 stops under the reading. The black then rendered as black and Stephanie rendered as beautiful.

his black tuxedo. Now, your in-camera meter says $^{1}/_{125}$ second at f/2.8 and ISO 100, so you snap a few frames.

When you get back to your computer, the images of the bride are dark and muddy. What could have happened? You followed your meter. Well, unfortunately, that reflected light meter was simply telling you how to render your subject as middle gray. As a result, the bride's exposure of $^{1}/_{250}$ second at f/8 and ISO 100 was 2 stops too dark. The dress was not middle gray; it was 2 stops brighter than the meter had indicated: $^{1}/_{125}$ second at f/5.6 and ISO 100.

The groom's picture is no better—he is blown out and way overexposed. Again, the meter led you off track, providing the correct exposure for recording his black tuxedo as middle gray ($^{1}/_{125}$ second at f/2.8 and ISO 100) while it was actually 2 stops darker than that ($^{1}/_{125}$ second at f/5.6 and ISO 100).

Did you notice something there? As it turns out, the exposure settings needed to render the dress white and the tuxedo black are identical: $^{1}/_{125}$ second at f/2.8 and

ISO 100. For the dress, this is 2 stops over the metered reading; for the tuxedo it is 2 stops under. Of course, it makes perfect sense that the subjects would both be correctly exposed at the same setting—after all, the light on the bride isn't different than the light on the groom. The only difference is how much of that light the two different outfits reflect back to the camera's meter.

SAMPLE SHOOT: Toronto Windows. Image 6-22 was taken in Toronto. I loved the bricks and the colors and all the specks that were a mix of leaves and paint droppings from construction overhead. When I first picked up the camera and aimed it at this scene, it wanted me to shoot 1 full stop darker than I ultimately did.

To get the exposure I envisioned, I carefully metered the gray bricks with my Canon 80–200mm L f/2.8 lens at full extension. I decided to place them at middle gray in the image. I also metered the white bricks at the bottom and found that they were 1.5 stops brighter, which seemed about right to me. **Image 6-20** show the shot as it came out of the Canon Raw converter.

As you can see, the histogram it is slightly to the right—but a quick look at the scene will show you why: there are a lot of areas of the scene in that middle-gray to light-middle-gray range. I wanted to make sure I got the glow of the light bulb in the window as well, so keeping the exposure tight to the middle gray was important. The completed image required very little work in Photoshop to render the colors and values I wanted.

IMAGE 6-20 (RIGHT). The image straight out of the Canon Raw converter.

IMAGE 6-21 (BELOW). The histogram from the Canon software.

IMAGE 6-22 (BOTTOM). The final image.

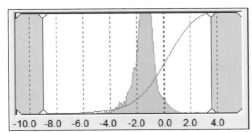

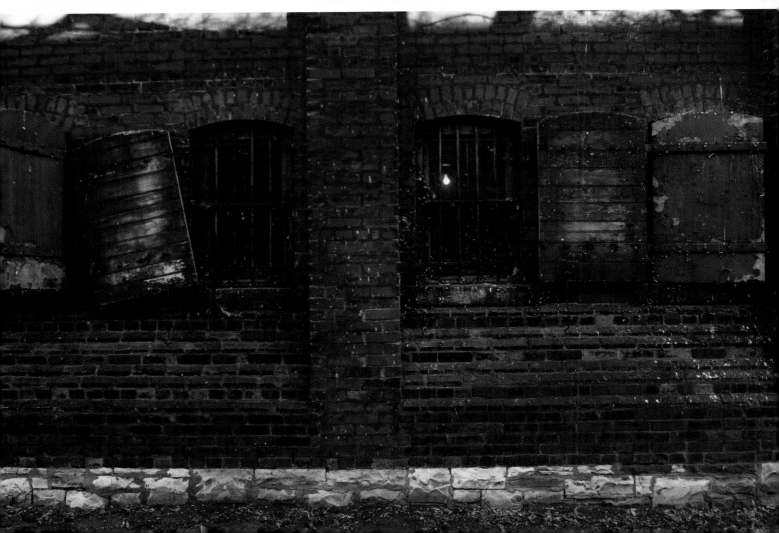

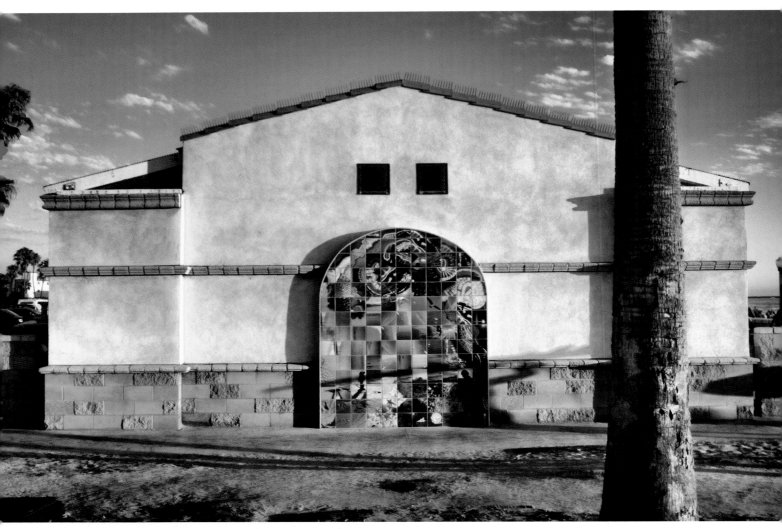

IMAGE 6-23. Choosing an exposure setting 1 stop over what the in-camera meter recommended was the right choice for this scene.

SAMPLE SHOOT: San Diego Mosaic. This mosaic in San Diego was surrounded by a very bright wall and lit by very bright sun from low on the horizon (**image 6-23**). I metered it with my Canon in spot meter mode, but the meter suggested an exposure that was nearly a full stop under what I chose for the image. It wanted the bright wall to be middle gray; I wanted it to be 1 stop brighter, ensuring that the shadows on the area of the mosaic to camera left wouldn't recede into total darkness. This also gave me the richness of color I wanted and guaranteed that the wall would retain the texture that made it interesting. By placing the exposure at a point that made sense to me, and for the subject, I was able to capture an image that feels like I remember the scene. Very little Photoshop was used on this image—just a mild contrast tweak. (Digital is so flat; I frequently have to boost the contrast to suit my taste.)

AMBIENT LIGHT METERS

Ambient light meters (also called incident light meters) measure the light falling on them. Placing the meter in the same light as the subject you want to photograph will give you an exposure reading that is totally independent of the subject's tonality. This is because the light is measured *before* it hits the subject, not after some unknown percentage of it has bounced off the subject (as with reflected light meters). It doesn't matter what the luminance of the subjects might be; white will be

rendered as white, black as black, and middle gray as middle gray.

Additionally, the dome (the light-sensing element) on an ambient meter is three-dimensional—just like most subjects. This means it accepts light just like a subject does, with a lit side, a transition area, and a shadow side. The result is an accurate representation of the ambient light in the scene you are metering. This is a distinction that becomes very clear the more you use the ambient light meter. Whether in shadow or sunlight, the meter will give you the accurate exposure information you need to make decisions about your capture.

I use ambient meters more than reflective meters in my commercial work and digital photography. The control I get from the ambient meter is something I have learned to treasure.

Using an Ambient Light Meter. In all circumstances, I point the meter dome toward the camera. I also make sure that extraneous light (any light that will *not* be hitting the subject) does not hit the dome. Doing this when there is back light coming over the head is particularly tricky. Even a little spill coming over and glancing onto the dome can change the reading—but that light won't be *in* the image, as the model is blocking that light from the front of her face.

To meter for the main light exposure, I place the meter under the subject's chin in the same light as the subject and facing the camera. That means that the meter will, in most circumstances, be getting the same light as the face.

I can also use the ambient meter to measure a secondary light's exposure. In the example shown below, I held the meter to Stephanie's back in order to read the light from behind her. The difference between those two readings is called a ratio—and I want to know what the ratio will be when using two light sources. Controlling the ratios between the lights is just as important as controlling the exposure itself (we'll be looking at this in the next chapter).

SAMPLE SHOOT: Spokane Radio Towers. I didn't have to trudge all the way over to the radio towers (im-

IMAGE 6-24. This is my trusty Minolta IV. It has been on every shoot I have ever done—except for that terrible time it sat alone in a Las Vegas hotel room as I headed out 100 miles into the desert for a big shoot. It has dings and chips and scrapes and I lost the case a year ago in San Francisco, but I still love it. It hangs from my neck before the shoot and sometimes late into the evening during dinner and conversation. I keep it safe and I use it when I need it. It has rarely failed me. When it becomes unusable, and it will someday, I will search for another one on Ebay. (Once I get used to a tool, I like to keep using it.)

IMAGE 6-25. To meter for the main light exposure, I place the meter under the subject's chin in the same light as the subject. In this case the light is a small softbox with a strobe in it.

IMAGE 6-26. I held the meter to Stephanie's back in order to read the light from behind her.

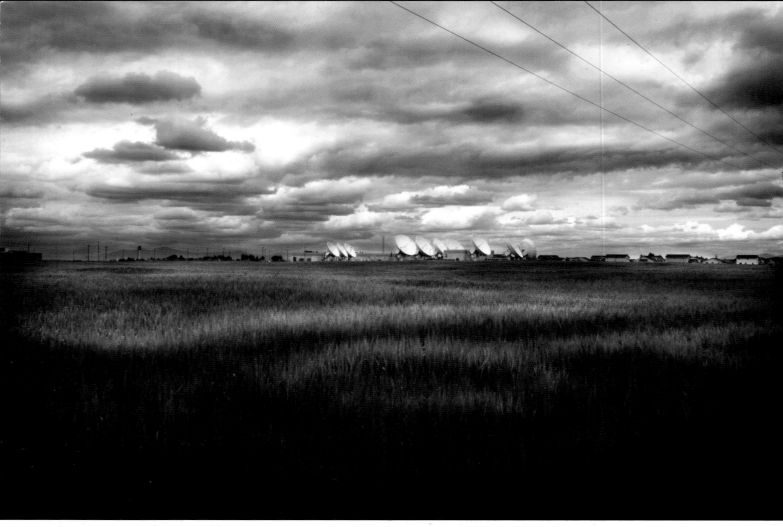

IMAGE 6-27. Because I was in the same light as the radio towers, the ambient light meter gave me a dead-on exposure.

age 6-27) to take an exposure reading. I was using the ambient meter, so I just made sure I was in the same light as they were and then held the meter in front of me aiming back toward the lens axis of the camera. The resulting exposure was dead-on; the ambient light meter gave me the exact reading I needed to make the shot without having to individually meter the white radio towers, clouds, and grass. Very mild Photoshop was used to bring the clouds into a closer tonal range to the grass and the towers.

IMAGE 6-28 (FACING PAGE). This head shot of Briana has a lot of great light happening in it. The main light was a medium grid spot placed pretty close to the subject. The backlight was a small reflector positioned very close to the wall to reduce the spill from it. The third light was a small speedlight set at very low power and placed in very close to the back of her head to provide a small, bright hair light.

IMAGE 6-29 (LEFT). You can barely see the grid spot in this setup shot, so I highlighted it with a white border.

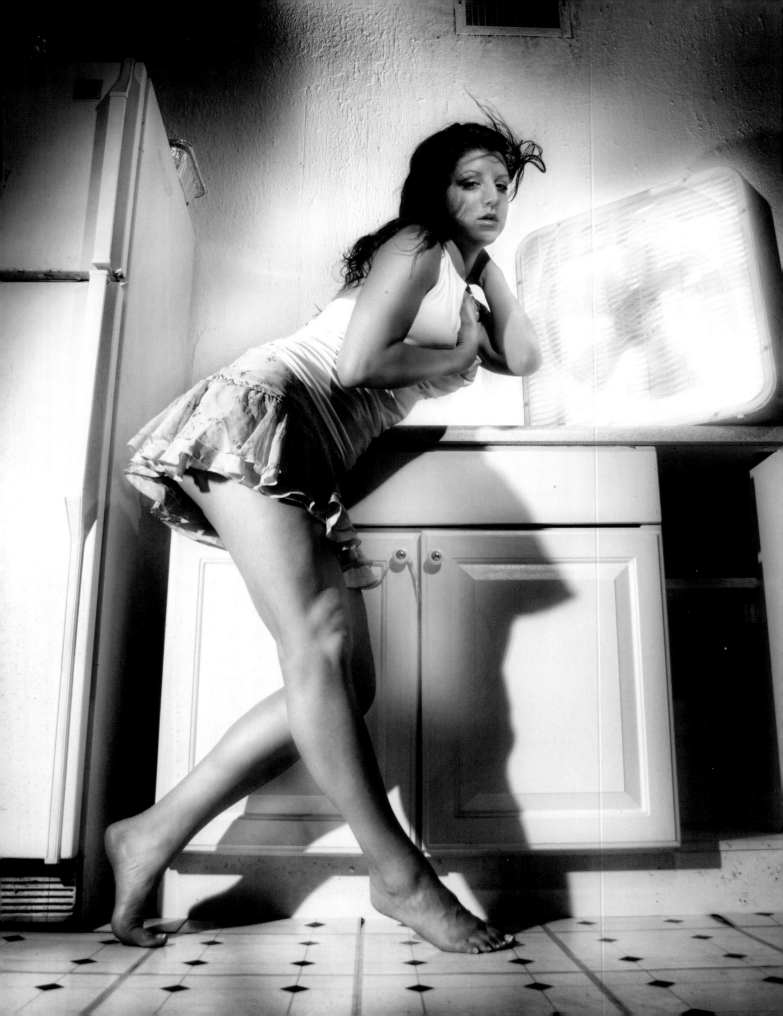

7. CONTROLLING THE LIGHT AND SHADOW

I am sometimes amazed how many online discussions there are about the evils of shadows. Shadows are a natural result of light, so I'm not sure that killing *all* shadows is the best way to light *everything*. Sure, there are some cases when a shot requires nearly or completely nonexistent shadows, but for the most part, we define the light by showing the shadow—even a very faint one. Shadows tell us the direction of the light just as certainly as the highlights do. Shadows define and sculpt, create contrast, provide modeling of the subject, and can be used to add an air of mystery to a photograph. Shadows are very important to photography, so we need to be able to control them and their relation to the highlights also produced by the light that created them.

CONTROLLING THE SHADOWS

I love shadows. They give an image dimension and depth, mystery and grace. Shadows can be fairly faint

and still help establish a background, the angle of light, or separation of the subject from the other elements in the picture. Conversely, they can be quite strong and add a hard "edge" to the image. Subject-centric light-

IMAGE 7-1 (FACING PAGE). This image of Briana was photographed at a motel on Anna Maria Island. It was raining like heck and we couldn't leave the little laundry room to wait for our ride to the airport, so we decided to make photographs. I placed one speedlight behind the fan (it was spinning; the strobe froze the blades) and one on a stand behind her to camera left, putting the shadow of her legs on the laundry sink. A third light was placed high and focused on her face. Each light was set to the same output, and their careful placement meant that she didn't have a lot of leeway in her movement. The shadows are a big part of the feel of the final image, giving it a whimsical look that wouldn't have been present with flat or one-sided lighting.

IMAGE 7-2 (RIGHT). This shot of Richelle and the chair is made more interesting by the shadow on the wall. Shadows are not the enemy of photography, they are part of what we do.

ing means knowing how to create the types of shadows you need and place them to portray your subject in the way you have envisioned.

The Angle of the Shadows. Shadows are created by a light source, so they fall away from whatever object blocked that light (creating the shadow) at the same angle as the light hit the obstruction. For example, if the light is coming in toward the subject at a 30 degree angle, the resulting shadow will also be at a 30 degree angle. Shadow is, after all, just the light interrupted.

The Quality of the Shadows. As you learned in chapter 3, light sources that are large in relation to the subject (or, more to the point, the obstruction) produce soft-edged shadows. Light sources that are small relative to the subject yield sharp-edged shadows. If you're not clear on how this works, take a moment to re-read the section in that chapter covering the size of the light relative to the subject.

The Exposure of the Shadows. Shadows can be very light or very dark. One way to control this is by adding a light source on the shadow side of the subject. This light will "open" the shadow area—meaning that it will bring it closer to the exposure level of the main light side of the subject.

Many times, fill cards (reflectors) are used for this purpose. To do this, the card is placed on the shadow side of the subject and angled toward the face. Essentially, the card works like a mirror; light striking it from an angle (the angle of incidence) is reflected at an equal and opposite angle (the angle of reflectance). So when I put a fill card up next to a face, I make sure it is at the correct angle to receive as much light as possible from the main light and direct it onto the shadow side of the face, rendering the shadows brighter.

Alternately, you could add a second light source—or a third—to open up the shadows. There are boundless

IMAGE 7-3. On the whole, this image was exposed correctly; I like the way her hair is rendering and the white fence looks white. Unfortunately, it is not a good exposure for her face. To use the lighting as-is, I would have had to open up another ⅔ stop or so to compensate—but that would have changed the exposure of the whole shot.

IMAGE 7-4. Instead, I provided fill light on her face from a large white fill card in front of her. By controlling this, I made sure the face presented correctly (returning more light to the camera). Because the fill card only affected her face and the front of her shirt, the exposure for the rest of the scene remained unchanged—preserving what I liked about the previous image.

ways to have the subject be rendered by the light, and it is sometimes one's personal style that determines what approach will be used.

LIGHTING RATIOS

The exposure difference between two light sources (typically the main light and the fill light) is commonly described using a ratio—like "2:1" or "3:1." Controlling the ratio lets you adjust the relationship between the shadows and highlights on a subject. The most common lighting ratios used in portraiture are listed below:

> **1:1** means equal amounts of light on both sides of the subject
>
> **2:1** means there is two times more light (1 stop difference) on one side than the other
>
> **3:1** means there is three times more light (1.5 stops difference) on one side than the other
>
> **4:1** means there is four times more light (2 stops difference) on one side than the other

You can use a knowledge of ratios and how they look to help create the images you see in your head. I also find using ratios to be helpful when I have to do many shots that must match. Especially if those shots are to be created in different locations and on different days, knowing the ratio and matching it lets me design photographs that look like they were all taken at the same time—or are at least darn close!

LIGHTING THE FACE

The ability to control light and shadow is integral to making our portraits subjects look their best. I am about subject-centric lighting, so I begin making lighting choices by studying my subject's face and starting to light it in my head.

Although I don't like to follow any "rules" in particular, there are basic guidelines that make people look their best. For example, if the subject has a round face, I may tend to move the main light farther to the side to create more shadow—a slimming illusion. If it is a very long face, my light may drift back toward axis of

IMAGE 7-5. The sun was coming from camera right and was quite high in the sky when we did this shot. I put a small beauty dish with a speedlight to camera left and chose a ratio of 1:1—that is, I chose to match the sunlight in order to show the lovely skin tones. There is a highlight from the sun and a highlight from the beauty dish. There are only subtle shadows visible here as the two lights match each other.

camera to fill more of the face with light; the reduction of the shadow area will make the face look a bit wider and hopefully mitigate its length. If the subject's nose is large, I will make sure it doesn't cast an equally large shadow.

Another appearance challenge that can be controlled using light and shadow is bad skin, which is simply a texture problem. As you may recall from chapter 3, it

WORKING IN THE TRANSITION AREA

One area of lighting that gets overlooked is the transition area, the place where the main light starts to transition over to the shadow—the "edge" of the light, so to speak. This complex area can provide light that is both highlight and drop-off, helping you create images with more dramatic effects. Using this technique, sometimes referred to as feathering the light, drama can be created by having the subject emerging from the shadows, or you might work with the light-to-dark transition as a compositional element. In any case, you can use light transitions for very interesting effects. Even in totally natural light, there is a transition happening somewhere.

is a combination of highlight and shadow that reveals texture. This is increased by placing the light at more of an angle to the subject. For example, sidelighting an old brick wall brings out the texture and makes a killer shot. Sidelighting a kid with bad skin also brings out the texture—and he'll want to kill you for doing it. Instead,

you can mitigate the texture by reducing the difference between the highlight and the shadow. Flatter, softer light reduces the appearance of texture, so a large light source from at or near the camera axis will eliminate the shadows that reveal those little bumps, crevices, and scars. It will also reduce the time you need to spend retouching this image in Photoshop. Big difference.

Beyond the simple goal of flattering the subject, however, I want to create a portrait that says something about the person in it. I want to open the viewer to the persona and yet carefully control how it is perceived. I want to create something that is powerful and sublime. Study your subject. What makes them unique? What makes them be a subject for you? What do you want to say about them? What do they want you to say about them?

Contemporary portraiture isn't about rules, it is about emotion and clarity—as well as obfuscation and mystery. There must be a genuine desire on the part of the photographer to do something nearly magical with their depiction of the person in front of their camera.

IMAGE 7-6. Sidelighting across the silos and the field accentuates every little bit of texture. If this were skin, it would do the same thing. Keep that in mind when you are photographing subjects with less-than-perfect skin. Adjusting the angle of the light source is a powerful way to enhance or conceal texture.

IMAGE 7-7. Using a small softbox with a speedlight on a boom (main light) and the hazy sun (backlight), I created this shot of Briana in Superior, AZ. I brought the softbox in close for soft light with fast fall-off. I also placed a speedlight on a very tall stand behind her for a spray of light on the mural. It was placed right behind her shoulders and set to match the main light, creating a bright area in the center of her shoulders that slowly faded out toward the edges. Her face is turned toward the light, and the resulting shadow on her face helps to sculpt her features.

LIGHTING THE SUBJECT OR THE SET

I always think of lighting in terms of two general camps: subject-specific and set-specific.

Lighting the Subject. Subject-specific lighting is designed for a specific set, pose, and situation. As a result, subject-specific light is far more nuanced than set-specific lighting. It is often so tightly controlled that the model has very little (if any) room to move; the light is configured for that specific pose and position. Lots of beauty, fashion, and editorial shots are created using this approach. It is how I mostly work, as well; I create the shot I see in a set that is appropriate, then add the light on the subject to make them look like I want. Moving the subject around means moving the lights to follow the subject's place on the set.

Lighting the Set. Set light is a more general approach that allows the subject to move around within the light. Think about lighting for dancers or ice skaters; they need to move to make the shots work. For moving subjects, I light the set rather than the subject,

giving them some latitude in their position. We still have marks to hit and we prepare specific lighting for different places in the set, but the subject has much more freedom.

When preparing a set for subjects that move, I usually place the lights farther from the subject than usual. If you remember the Inverse Square Law, this puts the subject at a distance where the light's intensity is changing more gradually. As a result, the subject can be a little off their mark without being under- or overexposed.

You can think of this as cinematic lighting, where an actor is able to move through the set. The light will interact with them differently depending where the subject is in the lighting scheme. Using this approach can help get your models moving and keep them engaged with the camera.

KEEP THEM IN THE LIGHT

After you have visualized that final image and are on the way to making it a reality, you have to make sure your

IMAGES 7-8 AND 7-9. For this shot of Desean, moving the lights far enough away for him to be able to move was very important. Using larger umbrellas kept the light somewhat soft, but with enough modeling to make it interesting on his face and body. The final photograph was shot from a very low angle to make it appear as though he was really flying.

IMAGES 7-10 AND 7-11. This is a similar setup for a shot of Briana leaping way into the air. It's so nice to have a cove in the studio that allows me to shoot upward without going off the background. Below is my final shot of Briana jumping way up in the air.

IMAGES 7-12, 7-13, 7-14, 7-15, 7-16, AND 7-17. This series of images shows what happens when the model moves through the light source. Here, the light remained in place and the model moved her face from an on-axis to a full-sidelight situation. You can see that the shadows produced are larger as she moves away from the axis of the light.

subject is in tune with what you are doing. If you have set your main light and fill up for a specific shot, it is not going to work the way you envisioned if the model turns away from the main light or twists in ways that prevent the main light from being the main at all.

I involve the model in the shots I am working on. I show them what we are working toward and tell them what they need to do to stay in the light we are working with. Most subjects understand and work hard to deliver. They feel that the resulting image is a collaboration. That is as it should be.

I shoot tethered most of the time so we can see the image larger than on the camera's little LCD screen. (On location it is a bit more difficult, but whenever I can, the camera is hooked up to a laptop.) This makes it easy to show the model what I am trying to accomplish. Letting them get a feel for the shot also increases the emotional impact—and many times they have great ideas themselves. I love portraits that are a true collaboration. (*Note:* When shooting still lifes I rarely show the subject what I am doing—unless it is very late, I am very tired, and the music is way too loud.)

8. DESIGNING THE IMAGE YOU WANT

Previsualizing an image that conveys the intended message about your subject is the beginning. This process, and its fundamental importance, was covered in chapters 1 and 2. Knowing what type of lighting tools you are going to need is the next step; this was covered in chapters 3 through 7. With these concepts in mind, we can now move forward and see how everything comes together in actually designing a shot.

SKETCHING

Many variables come into play as we transform our three-dimensional world into two-dimensional images. In and of itself, the process will change the apparent relationships between the space, the light, and the subject. If natural light is being used, this can change from minute to minute. In the days of film, we could only preview these relationships using Polaroid film. Today, we can capture test images for review. I call this process "sketching."

Sketching reveals the subject and scene as they will appear in your final photograph. More importantly, it allows you to make sure that the tonalities, relationships, and values you saw in your head are all represented in that final image. You can shoot from different angles and with different lenses. Add a light, then add another—or maybe a fill board or a shiny reflector. As

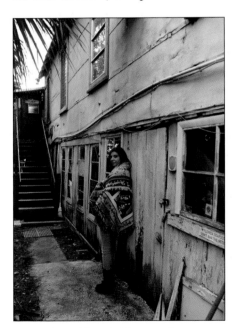

IMAGE 8-1. Although it's a good exposure, my first sketch of the scene was a little bit boring.

IMAGE 8-2. Underexposing by one stop made the background more dramatic—and would provide better contrast with the light I planned to add on the model.

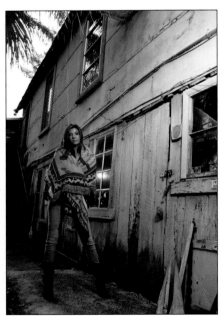

IMAGE 8-3. After adding the speedlights, my text sketch revealed a reflection of the backlight in the window. The easiest way to correct this was by repositioning the model.

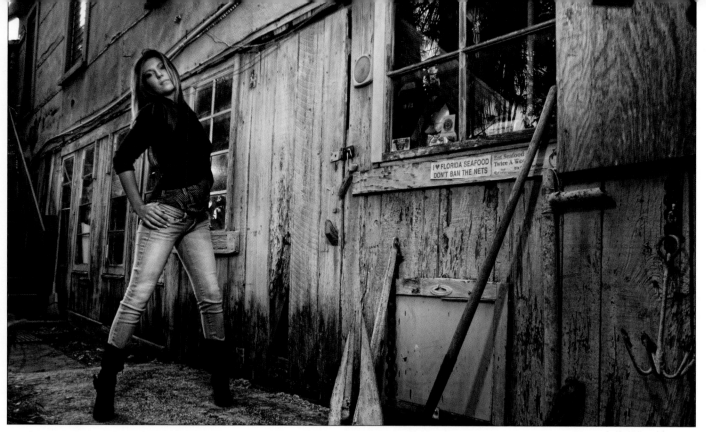

IMAGE 8-4. The final image was achieved after shooting several sketch images.

you adjust the highlights and shadows shade, you'll be creating a "road map" to the actual exposure.

I often work with sketching to find an angle that I want to explore or to evaluate how the foreground works in relationship to the background. When shooting outdoors, I will also see where my exposure choices will place the sky within the limits of the capture.

SAMPLE SHOOT: Portrait of Katlyn. For this shot, I found a cool place to work and knew I wanted to shoot Katlyn here with her gray wardrobe. Although it was a sunny day, I knew the light would be around f/4 on the shady side of this building. That meant I started at f/4 and ISO 100 at $^1/_{100}$ second. I shot an initial "sketch" image to see the ambient exposure (**image 8-1**). As you can see, it is a good exposure—but a bit boring.

I decided to place the ambient light at a stop under, so the light I was adding would be more interesting. I used the shutter speed (rather than the aperture) to make this adjustment so I would still have plenty of flash power and recycle time if I needed it (**image 8-2**). If I had decided to lower the aperture to f/5.6, I could

have accomplished the same one-stop-under look, but I would have had to increase the flash power (maintaining the distance I wanted) to bring the flash up to f/5.6.

I placed Katlyn in the position I liked and added the strobes. In front of her, I placed a small softbox with a speedlight. One bare speedlight was added behind her. Because the ambient was not very bright, the power of the lights was very low for this shot. I matched the back and the front speedlights to f/4 and did the next sketch. I noticed the reflection in the window behind her caused by the back speedlight (**image 8-3**). The easiest way to hide that was to put her in front of it. I also noticed that the light was very gradient in its presentation and quite bright in front. I moved the light away from the building and angled it away from the wall to get less light spill on it.

For the final image (**image 8-4**), you can see that I chose to do a horizontal composition instead of a vertical shot. This allowed me to include more of the wall and the texture. You can also see that I got down a bit lower to add some height to the subject.

IMAGE 8-5 (TOP LEFT). I knew I wanted to place Stephanie near the tall sculpture, so I began the sketching process by experimenting with this relationship.

IMAGE 8-6 (TOP RIGHT). The sketching process helped me to determine how I wanted to record the ambient light and how much light was needed on my subject.

IMAGE 8-7 (LEFT). The final image.

SAMPLE SHOOT: Portrait of Stephanie. I found this cool little place where they use chainsaws to cut artistic things out of palm tree trunks. I wanted to put Stephanie in the mix of it, so I began to sketch the scene. I don't worry about exposure on the subject at this point in the sketching. I want to simply see the shapes and items as they play out through the lens. I already knew that I wanted her near the tall sculpture, so I played with the foreground approaches (**image 8-5**).

I had my friend Bill step into the shot to get an idea of the lighting and decided to underexpose the ambient light by one stop (**image 8-6**). Adding the speedlight in a small softbox gave me a good idea of the exposure and how Stephanie would look when the flash lit her.

For the final shot (**image 8-7**), I added a bare strobe from camera right aimed at her midsection and set to expose at ½ stop over the ambient. This light, a ½ stop under the main light, added a little fill and highlight on her camera-right side. The sunlight added backlight and kept the foreground interesting.

SAMPLE SHOOT: Desean in the Lobby. Every time I enter the lobby of my studio, I admire the lighting from the clear skylight and bright white ceiling. For this portrait of Desean, I sketched the image out with my camera to find the ambient level that made sense to me. The ambient was very important; I didn't want to change the ambiance in the lobby, I wanted to capture it.

Once I had the ambient setting, I knew what I needed to add to the subject. I placed a single head into a shoot-through umbrella and set the power ⅔ stop brighter than the ambient. I shot at the ambient exposure, letting the light from the hallway glow brighter than the lobby.

The resulting image precisely captured what I saw in my head, with light from the hallway flooding in subtly to provide some depth.

START WITH ONE LIGHT

I have a method that has served me very well for over thirty years: I build each shot one light at a time. In the studio, I get the main light ready, and then add the secondary. If I'm working outdoors or in a daylight studio, I find the placement of the ambient light and decide what I want to do with it. Perhaps the image calls for the background to be a bit overexposed. Or maybe

IMAGE 8-8 (BELOW). The setup for my lobby image of Desean.

IMAGE 8-9 (RIGHT). This is the final image of Desean. You can see the feeling of the light from the hallway, which was a little brighter than the light from the skylight.

dropping the ambient light down a couple of stops will add a dramatic flair to the image.

When making these fundamental decisions about ambient light, there are some important settings that must be taken into consideration, of course. If you are going to use only the ambient light and fill cards, remember that there is no way to overcome the ambient—no way to make any kind of light that will be stronger than the direct sun. You also have choices to make about your aperture and shutter speed. Why? Because they can be whatever you want. With natural light, you are not limited by anything other than your lens's widest aperture and your camera's fastest shutter speed.

If you will be augmenting the ambient light with strobes, you'll need to have an idea of what you want to do before you begin to sketch. For example, if I know that I am going to be bringing in my large strobes, I

will set my camera to aperture priority (Av on my Canons) and choose the aperture I want to work with. My first consideration is aperture, but there is a real concern about the shutter speed, as well; I know that I cannot sync at shutter speeds faster than ¹⁄₂₀₀ second. If I chose f/8, then saw that the shutter speed dropped to ¹⁄₄₀₀ second, I would need to rethink my aperture—so the

exposure might be made at f/11 at ¹⁄₂₀₀ second. Most of the time I will walk the scene with my meter (set within the required parameters of the camera and sync speed) and make notes of the highlights, shadows, and midtones in the scene.

SAMPLE SHOOT: Stephanie on the Docks. I saw this image as I walked up onto the covered dock (**image 8-11**). I loved the incredible sky, the boats, the way the light was playing off the water, and the different shapes of the buildings around the background. I wanted to do something dramatic, so I sketched in a shot while we were setting up the boomed softbox.

I started by considering the ambient light. This seemed to be sufficient for the background feel I want-

IMAGE 8-10 (LEFT. The setup for my image of Stephanie.

IMAGE 8-11 (BELOW). The direct strobe from the left adds some nice highlights and the softbox from the right gives her face the soft light I wanted. The sun gave me some wonderful shadows coming in from behind, and the look was what I saw in my head when I walked up to the scene.

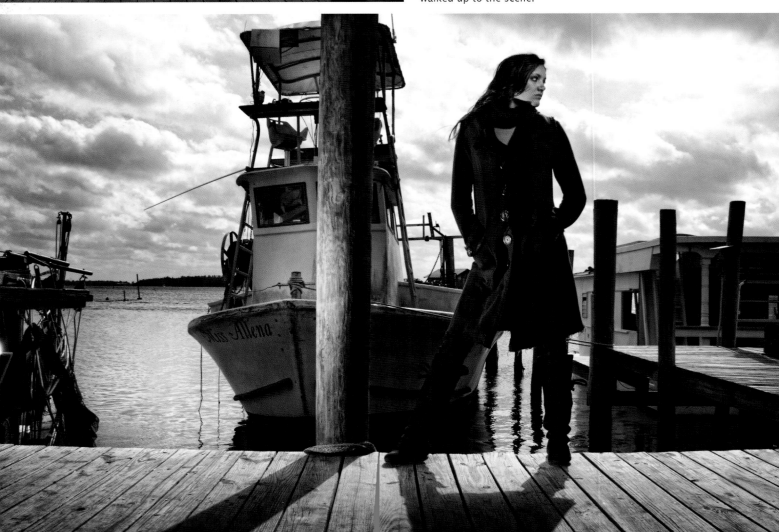

IMAGE 8-12. Building one light at a time allowed me to design the image of Jazmin I envisioned when I saw this location.

ed. However, I needed more light on Stephanie, so I added a softbox on a boom to illuminate her face and jacket. With the ambient light on the background and the main light on Stephanie in place, I determined that the light from camera left was a little lacking. Adding some light from that side would create a more dramatic, three-dimensional feel in the shot. Therefore, I placed a bare strobe at a low angle to camera left. I wanted the light to seem like a reflection on her, not a "full light" as from an instrument.

SAMPLE SHOOT: Jazmin and Column. For this shot (**image 8-12**), Jazmin was posed on a column at a beach house we used during a workshop in Mexico. The sun was on her face and I knew the light would be a perfect "Sunny 16" on her. But that also meant that the shadows would be too dark for what I saw in my head.

Knowing this about the ambient light, I added a speedlight at f/11. This was aimed it at the shadow side of her. I immediately saw that I needed another light to add something to the ceiling; it was going far too dark. I aimed this speedlight at the ceiling but away from the camera. I wanted it to produce an "open shadow" feel, not look lit, so I settled on getting an f/8 on the ceiling—two stops away from the f/16 ambient level. The resulting image has a nice feeling of light to it, with just a little drama. Jazmin added the wonderful pose and I got the shot in only a few exposures.

The point is this: Don't try to get it all at one time. Building the image one light at a time lets you see the possibilities—and alerts you to places to improve. After you do this for a while, it becomes second nature; while you may be building the setup one light at a time, you

"KNOWING" THE EXPOSURE IN AMBIENT LIGHT

I have a method that works pretty well for me. It is based on the Sunny 16 Rule that we looked at in chapter 5. These values are based on shooting at ISO 100 (and, accordingly, a shutter speed of $1/100$ second). (*Note:* What is in the scene all around can make a difference as well. Lots of bright buildings and a bright sky can open up the shadow exposures by $2/3$ to 1 stop in some conditions, but these values offer a pretty darn good starting point in most situations.)

in direct sun:	f/16
side light in direct sun:	f/11
backlight in direct sun:	f/8
on the shadow line (within 2 feet of edge):	f/5.6
5 to 7 feet into the shadow:	f/4
8 to 12 feet into the shadow:	f/2.8

From here, it is a process of elimination. Looking into a shadow scene you know that at ISO 100 and a $1/100$ second shutter speed, the exposure will be somewhere around f/4 or f/2.8. You know for sure it *isn't* going to be f/11. If you are in the sun, you also know for sure it *isn't* going to be f/4 or f/5.6. You know not to even start there as you're sketching the image. It helps to know that stuff. You can achieve your vision so much more quickly when you know where to start.

are thinking so far ahead that it feels seamless to those around you.

A FINAL NOTE ABOUT SERENDIPITY

When asked why I chose a specific light modifier for a shot, I can answer with all kinds of technical and artistic reasons about 70 percent of the time. The other 30 percent of the time, the selection was the result of me playing—mixing up the vision I have in my head with newer visions that pop in while I am working. (That "what if?" voice can be a true pest or incredible muse depending on how you hear it.)

Sometimes I grab a beauty dish just to see what it will do. Sure I can imagine it, but occasionally I want to *see* it—I want to play and let the fun lead me to new things. What would it look like to have the beauty dish as a bright sphere in the background? Let's try it. What about a grid spot on the hair? Sounds cool. Do one.

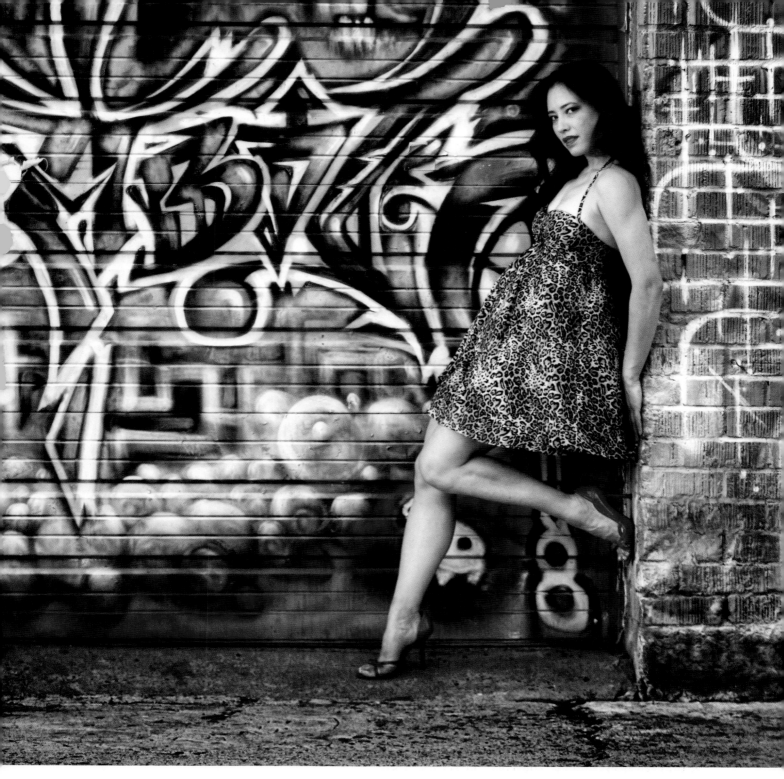

Certainly I want you to be able to visualize the image in your head before you go to create it, but at the same time I encourage you to take advantage of serendipitous moments and whimsical fun. The results can be pure magic.

IMAGE 8-13. Shooting in the alley behind my studio, the sun was very low on the horizon. While it was not directly on this little nook in the wall, it was plenty to bring in soft lighting for the shoot. I used a long lens and a shallow depth of field to allow for the fastest shutter speed I could get. Handholding a long lens is something that I was able to do with complete confidence for a long time. Lately, though, I am more often seeking the control of a tripod.

9. LET'S MAKE PHOTOGRAPHS

KATHERINE IN THE TREES (BRADENTON BEACH, FL)

I saw this image as soon as I parked the car. The trees were lined up and lit from the side. I liked the linear aspect of the trunks and the light that was hitting from one side was amazingly warm and inviting. I used a fill card to light her, and the silver board took up the warm color from the sky and put it back on her face. I wanted the image to have very little depth of field so Kather-

IMAGE 9-1. A fill card bounced the warm light onto Katherine's face.

ine would stand out from the background, so I used a long zoom lens (70–200mm Canon L) at f/2.8. The exposure was $\frac{1}{400}$ second at ISO 400. The short shutter speed ensured my handheld shot was sharp; it was quite cold and windy, so I wasn't taking any chances.

RIO IN THE LATE EVENING SUN (HOLMES BEACH, FL)

I instantly knew how I wanted to light this shot. The nearly still water and the great clouds were really a draw. The textures everywhere were really nice, so I decided to split light her with strobe and sunlight. To make the shot, I used two speedlights: one in a softbox and one bare. The softbox light provided soft fill from the camera position. The second light was placed on the dock to camera left and aimed right at Rio. This light, at a 90 degree angle, became the main to the softbox fill from the camera position.

In the first sketch image (**image 9-2**), the sky was way too bright. I thought it might be cool to not underexpose the ambient too much—but this shot showed that even if the strobe light were correct, not too hot, the exposure for the scene sort of sucked.

For the next image (**image 9-3**), I lowered the exposure of the ambient to see if a $\frac{2}{3}$ stop underexposure would darken the background enough to show her off against the water and the sky. It was—but also made it obvious that I would need another light on the front of the subject.

For the final image (**image 9-4**), I added a softbox for front fill light, opening her up more and providing a nice soft look on her face without the deep shadows of the side lighting.

IMAGE 9-2. In the first sketch image, the background was way too bright.

IMAGE 9-3. Reducing the ambient exposure helped the background but made it obvious I'd need more light on the subject.

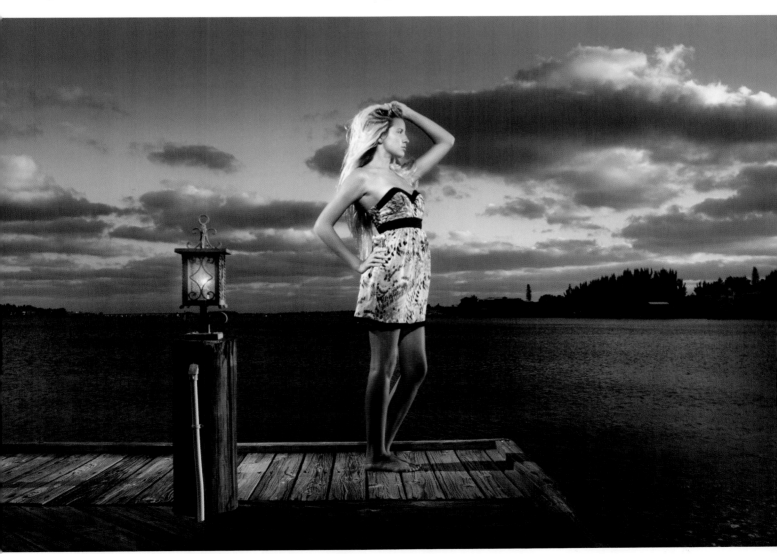

IMAGE 9-4. The final image.

KATLYN ON THE FENCE (NEAR LONGBOAT KEY, FL)

This shot of Katlyn (**image 9-5**) came about as soon as we walked out onto the little dock. The sun was bouncing off the water and creating a ton of highlights. I thought it would be cool to place Katlyn in front of those specular highlights and get the sun behind her for a halo effect.

Even though it was later in the day, I knew that the background light would be really bright—experience told me that the exposure would be somewhere around f/16 at $\frac{1}{160}$ second. So, I did a test shot at that exposure and the specular highlights on the water were way too hot. A second sketch shot at f/16 and $\frac{1}{250}$ second rendered a bit of texture in the very bright water. That would work. Finally, I needed to bring my softbox in close enough to get the light on her to f/16. I was at full power at this point, so placement was extremely important.

IMAGE 9-5 (LEFT). The final image of Katlyn.

IMAGE 9-6 (ABOVE). To make this shot, I backed up about a foot to reveal the light source. You can see how close it is to her—a necessity of the low power output of small strobes and the softbox modifier that is killing 2 stops of the power. This shot also reveals what happened when she put her chin down too low, creating shadows across her face.

IMAGE 9-7 (ABOVE). You can see David holding the fill card in front of Rio here. It was easy to get in this close with the fill because the light was somewhat soft. In full sun, the bounce would have been too bright.

IMAGE 9-8 (RIGHT). The final image of Rio.

SOFT SUN ON RIO (IN CORTEZ)

The soft sun in this shot (**image 9-8**) resulted from overcast conditions that were changing nearly every minute—but also casting beautiful lighting on Rio's hair. All I needed was right there in front of me: a subject, lovely light, and the graphic element of the fence leading to her. I chose a shallow depth of field, and for that I needed a long lens. The 70–200mm Canon L lens was selected and my aperture set in place. (*Note:* I love shooting wide open with this lens. It is sharp where it counts with just a little softness where it can do some good. It is one of the earliest Canon zooms, but it still holds its own against their new stuff. I hear it is called the "magic drainpipe"—and it sure is magical to me.) With a soft silver fill board in front of her to even out the light from the sun, an exposure of f/2.8 at $\frac{1}{640}$ second at ISO 200 gave me the shot I wanted.

IMAGE 9-9. The contrast was too high without the addition of fill.

IMAGE 9-10. The setup for the final image of Katlyn.

A CINEMATIC PORTRAIT OF KATLYN

I photograped Katlyn late in the afternoon when the sun was bright on the side of her face. My first shot showed that the sunlight without fill had too much contrast. The lit side and the shadow side were so disparate that the shot didn't feel right to me (**image 9-9**).

I wanted to make the shot more what I saw in my head than "natural," so I added some strobe from a softbox. The setup shot (**image 9-10**) shows where the placement of the small strobe was in relation to Katlyn.

IMAGE 9-11 (BELOW). The final image.

IMAGE 9-12 (RIGHT). An alternate final image from the same setup.

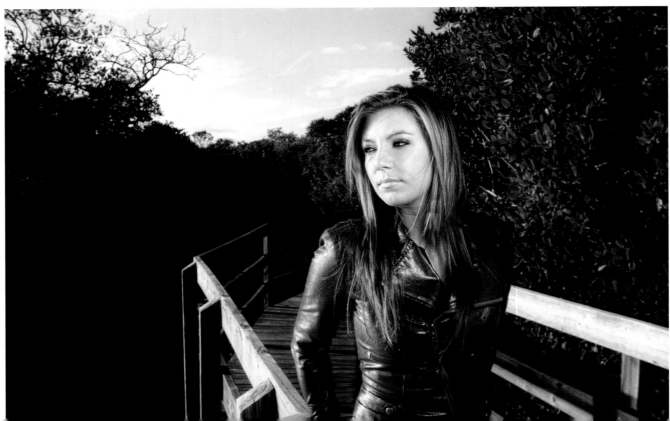

IMAGE 9-13 (TOP RIGHT). My first sketch image established the desirable level for the ambient light.

IMAGE 9-14 (BOTTOM RIGHT). The setup for the final image.

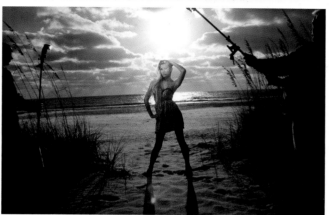

The box killed about two stops of light, so even at full power it had to be placed in pretty tight on her face. No matter, though; I like the way the light is dramatically revealed on her face (**image 9-11**).

Image **9-12** is an alternate shot from the set. Katlyn turned away from the sun and looked directly at the softbox. I like this shot a lot, and processed it a bit differently from the other shot. The softness of the light on her face, as well as the shadow that separates it from the sidelight of the sun, is intriguing to me. It has a far different feel than the other image.

RIO IN THE DUNES (ANNA MARIA ISLAND, FL)

I wanted Rio in the middle of the two little dunes with the grass on them. The sun was practically in the center, so we were good to go for an on-axis backlight. I took the first sketch image to establish my ambient exposure at 1 stop underexposed (**image 9-13**).

After placing Rio right in the center of the dunes, I brought in two speedlights. I used a small softbox on the front of her and a bare speedlight to camera left to add an accent to the shot. This added an edge to her right side (**image 9-14**).

IMAGE 9-15. The final image.

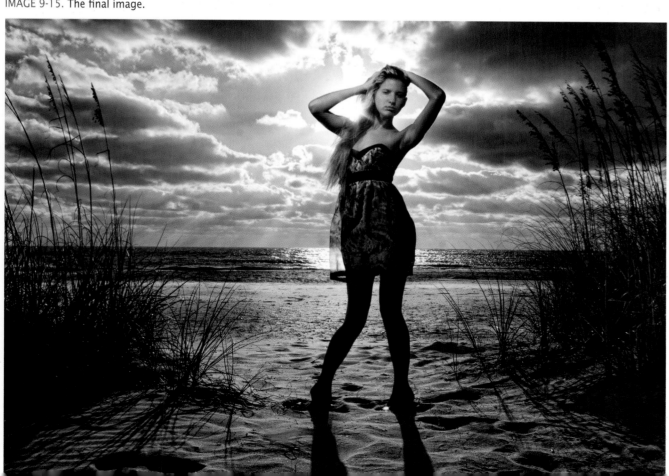

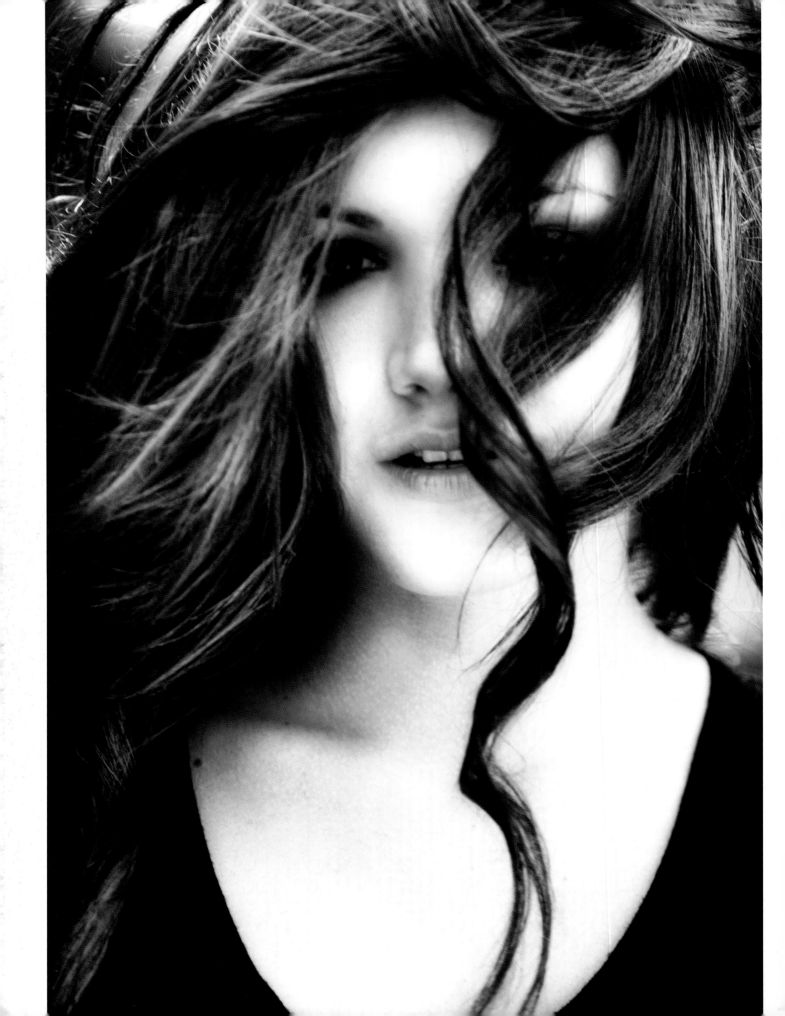

IMAGE 9-16 (FACING PAGE). An unexpected breeze made this head-shot of Stephanie more playful.

The final image, as processed (**image 9-15**), has a lot of drama. From her quirky pose to the light that is seemingly all around her, the image has a distinct flair to it. I love the sky with the incredible clouds and depth they portray in the image. The sun on the water adds a great background and a graphical element for her to be positioned over. I like doing this kind of portraiture; for me, it walks a nice line between accessible imagery and the fantasy styled, illustrative work that I like to do.

STEPHANIE'S HEADSHOT

Sometimes, chance presents something fun—and you just have to grab it. In **image 9-16** the wind came up unexpectedly and pushed Stephanie's curls into her face. I had to grab that shot and capture it forever (hey, that's what we do, right?), so I told her not to move and brought a small white board in close to her for a very slight fill. The sun was playing with the clouds and I had very slight backlighting from it. The resulting image was just as I saw it—mysterious and playful at the same time.

DESEAN DANCING

Desean got right into the spirit of this session (**image 9-17**), even though he's not a dancer. This leaping shot was exactly what I saw when he walked on to the set. It presents as sort of a hybrid between the old-school Gene Kelly kind of thing and new-school jazz. I had Desean positioned between two umbrellas in order to give him room to move and remain in good lighting. He leaped and I shot. He jumped into a similar pose about twenty times, but this was the shot that really struck me when looking at the digital proofs. I like his body language and the great highlights on his face and vest.

IMAGE 9-17. The final image of Desean.

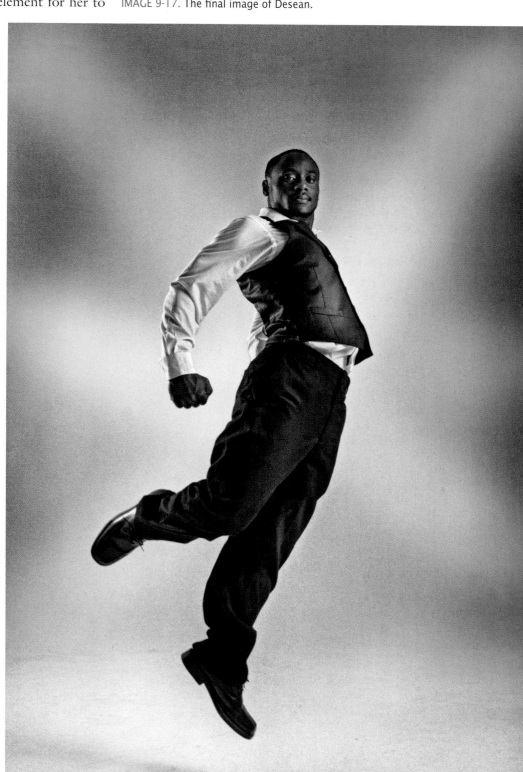

BRIANA ON THE PIER (MEXICO)

Ahhh, the joy of Mexico after the humidity has gone—unfortunately, it was still with us on this fine September afternoon and we were all about done in from the heat and dampness. I wanted to do a shot that showed clearly how we all felt, so I asked Briana to stand in front of the sun so I could shoot from her shadow. My first capture was done with just the natural light (**image 9-18**).

Next, I added a small beauty dish on her face from above and slightly to camera left. I added a second flash down low, aimed at her legs from camera right. I set that flash at a stop less than the main light so it would not overpower or even match it. I wanted to show the legs, not necessarily "light" them.

In the final capture (**image 9-19**), the sun played its part and produced little specular highlights on the ocean. The halo effect around her added to the "hot summer day" look I was after. I also love the shadows that race toward me and lead the eyes back to Briana.

IMAGE 9-18 (ABOVE). This is the shot with the natural light only.

IMAGE 9-19 (LEFT). The final image of Briana on the pier.

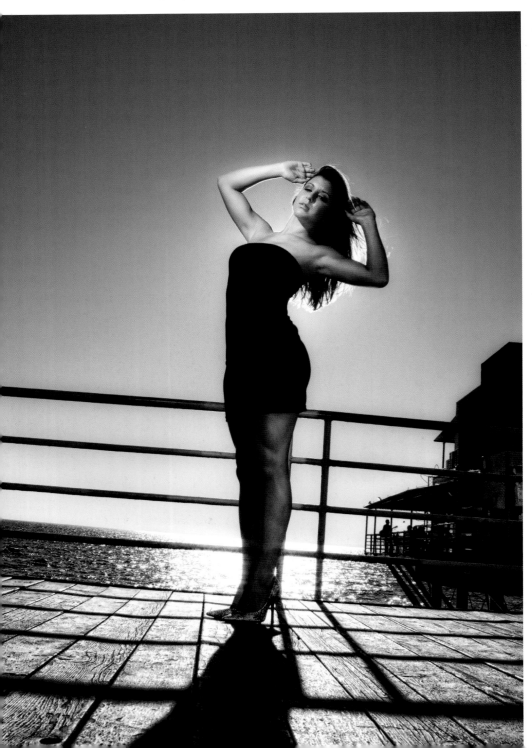

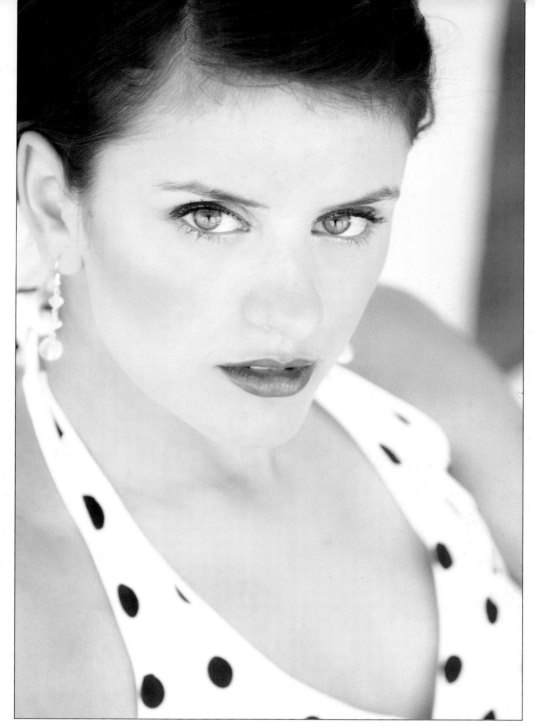

IMAGE 9-20. This simple headshot of Jazmin was created in the shade.

JAZMIN ON THE PATIO (MEXICO)

This simple headshot (**image 9-20**) was created in the shade on a Mexican veranda. If you look at someone in the shade, you may think they are "un-lit," but that's because your eyes are picking up *all* the ambient light and forming subjective relationships. Remember that you can place the exposure and begin to think of the light as being an objective tool of exposure.

We were both in the shade here, and my exposure was set to f/2.8 at 1/125 second at ISO 100. I could have shot it at f/4 or f/3.5, but I wanted that very open skin tone that the 1-stop overexposure gives in the shadows. The fill came from the surroundings on the rooftop veranda. You can see the light sources if you look carefully at the catchlights.

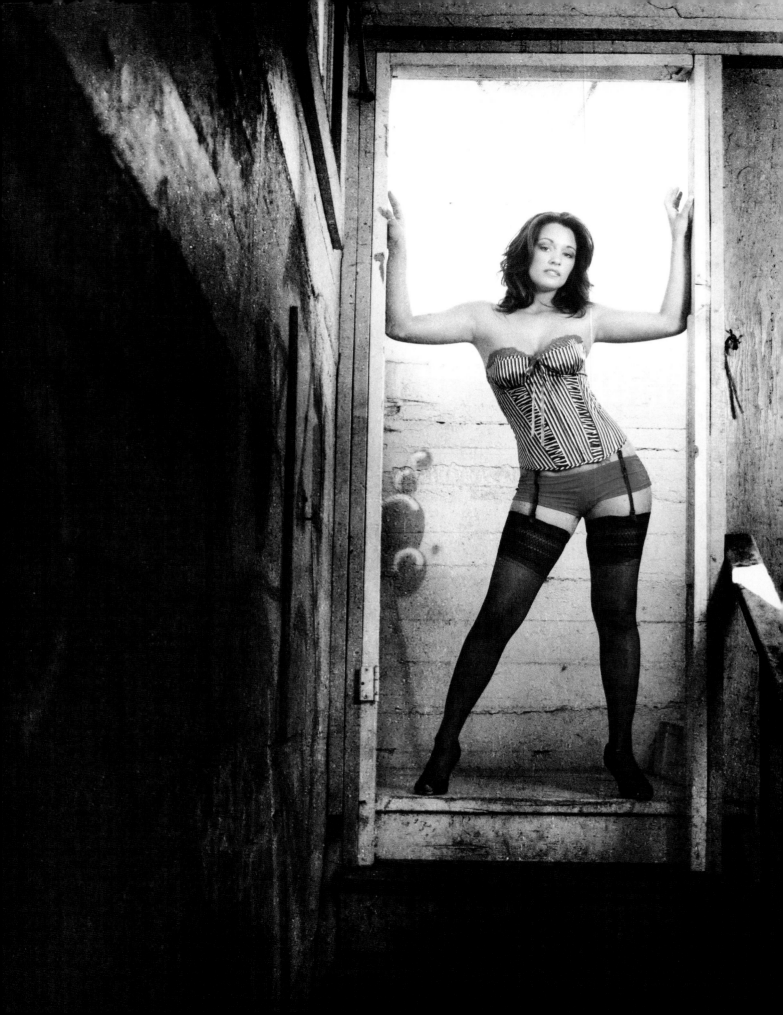

RICHELLE IN THE DOORWAY (PHOENIX, AZ)

Deep in the hallows of a large, abandoned building we decided to shoot a portrait of Richelle in lingerie (**image 9-21**). Why? Well, seemed like a good idea at the time.

The hallway behind her had stairs coming down and a little bit of light from a window. I saw her in the doorway and knew I wanted to exaggerate the existing look of the lighting from that window. Placing a speedlight in the hallway and aiming it up to bounce off the ceiling allowed me to light the background fully. With the addition of this source, the little dark stairwell turned into a highly lit area.

To light Richelle herself, I added a 43-inch umbrella to camera right, positioning it so it was tilted down toward her at a very slight angle. I adjust the power of that light to match the light on the white wall behind her, then dropped it 1 stop and shot at that aperture. That means the background light was 1 stop brighter than the light on her face and body. As it spilled out around her, it added some dimension to the image.

LYNNE AND THE RED LOCKERS

I used movie lights—hot lights fitted with fresnel lenses—to create this shot of Lynne in lingerie in front of a bank of red gym lockers (**image 9-21**). I put one light on a Century stand to camera right and aimed it slightly past her face to the camera. The second hot light was placed on a high stand behind her and aimed to light the lockers and the back of her head. This created some much-needed tonal separation. A third light was placed behind her to camera right and aimed slightly over her head. This lighting scheme resulted in a very nice, modeled wash of light. I added some fill cards to camera left to open up the shadows a bit.

IMAGE 9-22. The final image of Lynne.

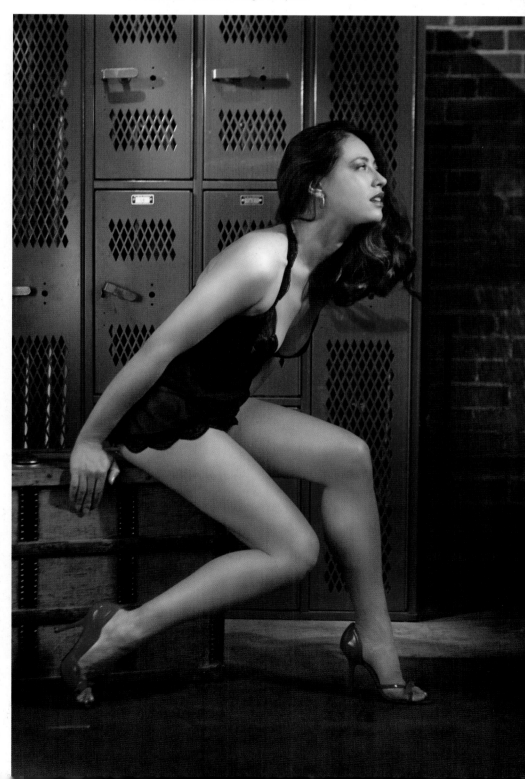

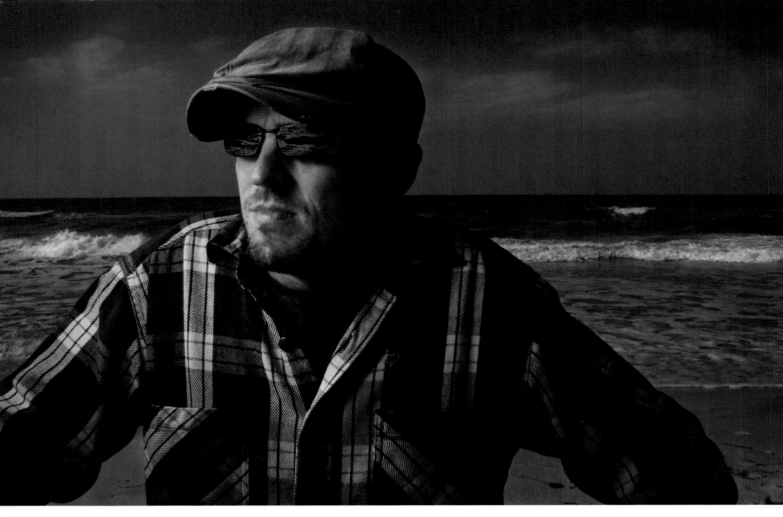

IMAGE 9-23 (RIGHT). This is the setup shot of the portrait of Keith on the beach. I think it is the mark of a true professional to have VALs of this caliber. (That's my story and I'm sticking to it!)

IMAGE 9-24 (ABOVE).The final portrait of Keith.

KEITH ON THE BEACH

This is a portrait of my good friend Keith Taylor (**image 9-24**). Keith is a photographer in Atlanta, GA, and joined us for a day in Florida at the Anna Maria Island Workshop. I wanted to do a portrait of him and we settled on the ocean as the background. It seemed appropriate since we were on the beach.

I used a VAL (a "voice activated light stand"—also known as an assistant) to hold the small umbrella quite close to Keith's face in order to get the exposure correct. I was shooting at f/16 at $\frac{1}{200}$ second and the speedlight was on full power blasting through the small shoot-through umbrella.

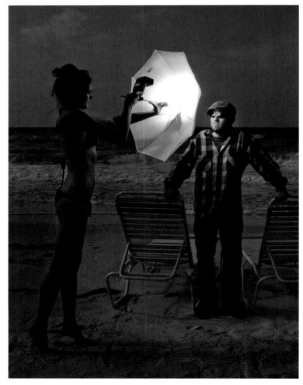

CONCLUSION

Thanks for purchasing this book. You can see and learn more at my blog, Lighting Essentials: A Place for Photographers, at www.lighting-essentials. com.

SOFTWARE AND HARDWARE

SOFTWARE

I use Photoshop to process my images—from mild postprocessing to the addition of textures and more advanced image manipulation. I want my images to look the way I see them in my head. From straight photography to illustrative techniques that give them a new and different look, I do it all. Most of my images are completed with between five and fifty layers.

I rarely use pre-made actions or plug-ins, but there are a few that I love:

- Mama Shan's Powder action is amazing (www.photoshopmama.net)
- Tony Kuyper Luminance Masks are something I use on nearly every image (www.goodlight.us/writing/luminositymasks/luminositymasks-1.html)
- Steve Burger's Pro Digital Image (www.pro digitalimage.com)

HARDWARE

Cameras My digital cameras are all Canon. Additionally I shoot film with an old Hasselblad, a Bronica 6x7, a Mamiya 6x7, two 4x5 cameras (one rail and one field), and a Deardorff 8x10. I still have my entire Nikon F3 kit in the closet—and a Canon EOS loaded with color negative film, ready to go on my next adventure. (Maybe we'll see each other out there making pictures.)

Lenses
- 20–35mm f/2.8 L
- 70–200mm f/2.8 L
- 50mm f/1.4
- 100mm f/2.8 macro

Lights
- Profoto Compacts
- Dynalite pack and heads
- Norman 2000 packs and heads
- Eight speedlights of assorted brands
- Three Mole Richardson 750Ks with fresnel lenses

Stands
- Three Century stands with booms
- One Savage boom extended
- Two Manfrotto booms
- Two Lumo Pro booms
- Twenty assorted light stands (and, yes, I need one more)

Other
- Three large Standbaggers (www.stand bagger.com)
- Two smaller Standbaggers for speedlights
- Two Pelican cases for lights and stands

INDEX

OTHER BOOKS FROM
Amherst Media®

WES KRONINGER'S
Lighting Design Techniques
FOR DIGITAL PHOTOGRAPHERS
Design portrait lighting setups that blur the lines between fashion, editorial, and traditional portrait styles. *$34.95 list, 8.5x11, 128p, 80 color images, 60 diagrams, index, order no. 1930.*

Understanding and Controlling Strobe Lighting
John Siskin

Learn how to use a single strobe, synch lights, modify the source, balance lights, perfect exposure, and much more. *$34.95 list, 8.5x11, 128p, 150 color images, 20 diagrams, index, order no. 1927.*

CHRISTOPHER GREY'S
Advanced Lighting Techniques
Learn how to create twenty-five unique portrait lighting effects that other studios can't touch. Grey's popular, stylized effects are easy to replicate with this witty and highly informative guide. *$34.95 list, 8.5x11, 128p, 200 color images, 26 diagrams, index, order no. 1920.*

THE DIGITAL PHOTOGRAPHER'S GUIDE TO
Light Modifiers
SCULPTING WITH LIGHT™
Allison Earnest

Choose and use an array of light modifiers to enhance your studio and location images. *$34.95 list, 8.5x11, 128p, 190 color images, 30 diagrams, index, order no. 1921.*

JOE FARACE'S
Glamour Photography
Farace shows you budget-friendly options for connecting with models, building portfolios, selecting locations and backdrops, and more. *$34.95 list, 8.5x11, 128p, 180 color images, 20 diagrams, index, order no. 1922.*

Multiple Flash Photography
OFF-CAMERA FLASH TECHNIQUES FOR DIGITAL PHOTOGRAPHERS
Rod and Robin Deutschmann

Use two, three, and four off-camera flash units and modifiers to create photos that break creative boundaries. *$34.95 list, 8.5x11, 128p, 180 color images, 30 diagrams, index, order no. 1923.*

CHRISTOPHER GREY'S
Lighting Techniques for Beauty and Glamour Photography
Create evocative, detailed shots that emphasize your subject's beauty. Grey presents twenty-six varied approaches to classic, elegant, and edgy lighting. *$34.95 list, 8.5x11, 128p, 170 color images, 30 diagrams, index, order no. 1924.*

Photographic Lighting Equipment
A COMPREHENSIVE GUIDE FOR DIGITAL PHOTOGRAPHERS
Kirk Tuck

Learn to navigate through the sea of available lights, modifiers, and accessories and build the best arsenal for your specific needs. *$34.95 list, 8.5x11, 128p, 350 color images, 20 diagrams, index, order no. 1914.*

Available Light
PHOTOGRAPHIC TECHNIQUES
FOR USING EXISTING LIGHT SOURCES
Don Marr

Find great light, modify not-so-great light, and harness the beauty of some unusual light sources in this step-by-step book. *$34.95 list, 8.5x11, 128p, 135 color images, index, order no. 1885.*

JEFF SMITH'S
Studio Flash Photography
This common-sense approach to strobe lighting shows working photographers how to master solid techniques and tailor their lighting setups to individual subjects. *$34.95 list, 8.5x11, 128p, 150 color images, index, order no. 1928.*

DOUG BOX'S
Flash Photography
ON- AND OFF-CAMERA TECHNIQUES FOR DIGITAL PHOTOGRAPHERS
Master the use of flash, alone or with light modifiers. Box teaches you how to create perfect portrait, wedding, and event shots, indoors and out. *$34.95 list, 8.5x11, 128p, 345 color images, index, order no. 1931.*

Wedding Photographer's Handbook, 2nd Ed.
Bill Hurter

Learn to exceed your clients' expectations before, during, and after the wedding. *$34.95 list, 8.5x11, 128p, 150 color images, index, order no. 1932.*

How to Create a High Profit Photography Business in Any Market, 2nd Ed.

James Williams

Timeless advice for maximizing your marketing efforts and providing top-notch customer service. *$34.95 list, 8.5x11, 128p, 150 color images, index, order no. 1933.*

Minimalist Lighting

PROFESSIONAL TECHNIQUES FOR STUDIO PHOTOGRAPHY

Kirk Tuck

Learn how technological advances have made it easy and inexpensive to set up your own studio. *$34.95 list, 8.5x11, 128p, 190 color images and diagrams, index, order no. 1880.*

500 Poses for Photographing Men

Michelle Perkins

Overcome the challenges of posing male subjects with this visual sourcebook, showcasing an array of head-and-shoulders, three-quarter, full-length, and seated and standing poses. *$34.95 list, 8.5x11, 128p, 500 color images, order no. 1934.*

500 Poses for Photographing Women

Michelle Perkins

A vast assortment of inspiring images, from head-and-shoulders to full-length portraits, and classic to contemporary styles—perfect for when you need a little shot of inspiration to create a new pose. *$34.95 list, 8.5x11, 128p, 500 color images, order no. 1879.*

50 Lighting Setups for Portrait Photographers

Steven H. Begleiter

Filled with unique portraits and lighting diagrams, plus the "recipe" for creating each one, this book is an indispensible resource *$34.95 list, 8.5x11, 128p, 150 color images and diagrams, index, order no. 1872.*

Digital Photography Boot Camp, 2nd Ed.

Kevin Kubota

Based on Kevin Kubota's sell-out workshop series and fully updated with techniques for Adobe Photoshop and Lightroom. A down-and-dirty course for professionals! *$34.95 list, 8.5x11, 128p, 220 color images, index, order no. 1873.*

Lighting and Photographing Transparent and Translucent Surfaces

Dr. Glenn Rand

Learn to photograph glass, water, and other tricky surfaces in the studio or on location. *$34.95 list, 8.5x11, 128p, 125 color images, diagrams, index, order no. 1874.*

Off-Camera Flash

TECHNIQUES FOR DIGITAL PHOTOGRAPHERS

Neil van Niekerk

Learn how to set your camera, which flash settings to employ, and where to position your flash for exceptional results. *$34.95 list, 8.5x11, 128p, 235 color images, index, order no. 1935.*

Wedding Photojournalism

THE BUSINESS OF AESTHETICS

Paul D. Van Hoy II

Learn how to create strong images and implement the powerful business and marketing practices you need to reach your financial goals. *$34.95 list, 8.5x11, 128p, 230 color images, index, order no. 1939.*

CHRISTOPHER GREY'S

Studio Lighting Techniques for Photography

With these strategies—and some practice—you'll approach your sessions with confidence! *$34.95 list, 8.5x11, 128p, 320 color images, index, order no. 1892.*

Mother and Child Portraits

Norman Phillips

Learn how to create the right environment for the shoot and carefully select props, backgrounds, and lighting to make your subjects look great. *$34.95 list, 8.5x11, 128p, 225 color images, index, order no. 1899.*

500 Poses for Photographing Brides

Michelle Perkins

Filled with images by some of the world's best wedding photographers, this book can provide the inspiration you need to spice up your posing or refine your techniques. *$34.95 list, 8.5x11, 128p, 500 color images, index, order no. 1909.*

THE DIGITAL PHOTOGRAPHER'S GUIDE TO

Natural-Light Family Portraits

Jennifer George

Learn how using natural light and fun, meaningful locations can help you create cherished portraits and bigger sales. *$34.95 list, 8.5x11, 128p, 180 color images, index, order no. 1937.*

Flash Techniques for Macro and Close-up Photography

Rod and Robin Deutschmann

Master the technical skill-set you need to create beautifully lit images that transcend our daily vision of the world. *$34.95 list, 8.5x11, 128p, 300 color images, index, order no. 1938.*

BILL HURTER'S
Small Flash Photography

From selecting gear, to placing the small flash units, to ensuring proper flash settings and communication, this book shows you how to take advantage of this new approach to lighting. *$34.95 list, 8.5x11, 128p, 180 color photos and diagrams, index, order no. 1936.*

Studio Lighting Anywhere

THE DIGITAL PHOTOGRAPHER'S GUIDE TO LIGHTING ON LOCATION AND IN SMALL SPACES

Joe Farace

Create precision studio lighting in any location, indoors or out, and achieve total control over your portrait results. *$34.95 list, 8.5x11, 128p, 200 color photos and diagrams, index, order no. 1940.*

Sculpting with Light

Allison Earnest

Learn how to design the lighting effect that will best flatter your subject. Studio and location lighting setups are covered in detail with an assortment of helpful variations provided for each shot. *$34.95 list, 8.5x11, 128p, 175 color images, diagrams, index, order no. 1867.*

Minimalist Lighting

PROFESSIONAL TECHNIQUES FOR LOCATION PHOTOGRAPHY

Kirk Tuck

Use battery-operated flash units and lightweight accessories to get the top-quality results you want *$34.95 list, 8.5x11, 128p, 175 color images and diagrams, index, order no. 1860.*

Family Photography

THE DIGITAL PHOTOGRAPHER'S GUIDE TO BUILDING A BUSINESS ON RELATIONSHIPS

Christie Mumm

Build client relationships that allow you to capture clients' life-cycle milestones, from births, to high-school pictures, to weddings. *$34.95 list, 8.5x11, 128p, 220 color images, index, order no. 1941.*

Flash and Ambient Lighting
for Digital Wedding Photography

Mark Chen

Meet every lighting challenge with these tips for shooting with flash, ambient light, or flash and ambient light together. *$34.95 list, 8.5x11, 128p, 200 color photos and diagrams, index, order no. 1942.*

500 Poses for Photographing Couples

Michelle Perkins

Overcome the challenges of posing couples with this visual sourcebook, showcasing an array of head-and-shoulders, three-quarter, full-length, and seated and standing poses. *$34.95 list, 8.5x11, 128p, 500 color images, order no. 1943.*

Posing for Portrait Photography

A HEAD-TO-TOE GUIDE FOR DIGITAL PHOTOGRAPHERS, 2ND ED.

Jeff Smith

This book will show you how to correct the most common figure problems, design poses that look natural, and craft images clients are sure to love *$34.95 list, 8.5x11, 128p, 200 color images, index, order no. 1944.*

Softbox Lighting Techniques

FOR PROFESSIONAL PHOTOGRAPHERS

Stephen A. Dantzig

Learn to use one of photography's most popular lighting devices to produce soft and flawless effects for portraits, product shots, and more. *$34.95 list, 8.5x11, 128p, 260 color images, index, order no. 1839.*

Professional Portrait Lighting

TECHNIQUES AND IMAGES FROM MASTER PHOTOGRAPHERS

Michelle Perkins

Get a behind-the-scenes look at the lighting techniques employed by the world's top portrait photographers. *$34.95 list, 8.5x11, 128p, 200 color photos, index, order no. 2000.*